GUESTBOOK

GUESTBOOK

Ghost Stories

LEANNE SHAPTON

RIVERHEAD BOOKS · NEW YORK · 2019

RIVERHEAD BOOKS

An imprint of Penguin Random House LLC
penguinrandomhouse.com

Copyright © 2019 by Leanne Shapton

Portions of "Eidolon" and "Middle Distance," in different form,
appeared in the Aspen Art Museum publication accompanying
Mary Ramsden's exhibition *In/It* (2016–2017).

Passages in "Eidolon" are from the screenplay for *Death in Venice*,
by Luchino Visconti and Nicola Badalucco (1970).

Cover art: Drawing of iceberg by *Titanic* survivor George Rheims,
presented in his deposition in *Titanic* liability hearings,
November 14, 1913.

Library of Congress Cataloging-in-Publication Data
Names: Shapton, Leanne, author.
Title: Guestbook : ghost stories / Leanne Shapton.
Description: New York : Riverhead Books, 2019.
Identifiers: LCCN 2018048143 | ISBN 9780399158186 (hardback) |
ISBN 9780525539070 (ebook)
Subjects: | BISAC: FICTION / Occult & Supernatural. |
FICTION / Psychological. | PHOTOGRAPHY / History.
Classification: LCC PR9199.4.S5255 A6 2019 | DDC 813/.6--dc23
LC record available at https://lccn.loc.gov/2018048143

Printed in the United States of America
1 3 5 7 9 10 8 6 4 2

BOOK DESIGN BY
LEANNE SHAPTON AND CLAIRE VACCARO

For Librada

A geist

A gust

A ghost

Aghast

I guess

A guest

—ADAM GILDERS, 1970–2007

Contents

GUESTBOOK

S AS IN SAM, H, A,
P AS IN PETER,
T AS IN TOM, O,
N AS IN NANCY

SAM HAS BLUE EYES. Ex–Royal Canadian Air Force, flew a B-25 bomber in World War II. Likes his sherry and salted butter and conservative politicians. He wants to cheer her up. Sam keeps watch with night patrols and lands birds on her windowsills. He is seventy-five percent deaf. He is seen in the reflection of the porch door.

PETER IS TALL FOR A FILIPINO, AND THIN.
He wears wide-wale corduroys in colors like rust,
mustard, and moss. His hips are broad, and when
seated in a chair, he crosses his legs at the knees. He
likes ketchup on most foods. He has big ears and
hands. His skin is the color of wet sand. Peter is
methodical. He is the one who keeps her safe. He is
the one who loves her and reassures her. He can be
heard as the murmur of company in the living room.

TOM DISAPPEARS
for weeks on end, but
when he is there he is
smiling and curious.
He is mischievous
with her fate and
capricious with her
time, putting things
in her path that
could spell disaster
or wisdom. Tom is
an augury. Tom is
a finger shaker and
letter writer. He can
play the guitar. Guests
have reported hearing
his music late at night.

NANCY HAS A BIG MOUTH. Opinionated, imperious, and uninhibited, she does not worry what anybody thinks. Nancy loves doing laundry. She launders everything. Nancy has big breasts and pushes them up. No qualms. Nancy is the one who makes her heart beat louder and her shoulders shrug. Nancy draws a circle around her. She holds her and is as dark blue as night, as white as noise. Sometimes there is the banging sound of sneakers in the basement dryer.

EIDOLON

DEATH IN VENICE
Screenplay by Luchino Visconti and
Nicola Badalucco, 1970

62. BEACH. HOTEL DES BAINS. EXT.
Tadzio has waded idly through the water and reached the sandbar.
To Aschenbach's eyes the boy seems an improbable apparition against
a foggy background without end.

As she is carried to the car after a Christmas party she nests her head in her father's neck. The purple sky is like her fingers, and the wind is cold and smells old. Her father sets her on the backseat, fastens her seat belt.

She's small, smells like sweet hair and pee, turds like little
birds collect in her pull-up. Her lead levels are normal. Her
sneeze like a wet tissue dropped on the floor.

Aschenbach rests his head against the chair-back, his arms relaxed at his sides, his head turned to watch the movements of the figure out there.

The car follows the cloverleaf onto a highway. The beam of a streetlight touches the hood and guides the vehicle along until the next beam picks it up. She falls asleep.

Horns on Fifth Avenue. She's forty-three and has opened
the kitchen window so the paint fumes won't linger with the
fettuccine, the strawberries, the water*lemon*.

*As though struck by a sudden recollection, or by
an impulse, Tadzio turns from the waist up in an
exquisite movement. One hand resting on his hip,
he looks over his shoulder at the shore.*

Her breath is eggy in the backseat. She stirs and looks at a
defrosting windshield in Bavaria. Blooms of clarity spread
across the glass.

Thirteen years ago she saw *La Bohème*. He picked her up in a town car on Jane Street. She wore a black corduroy suit and a pink scarf. They looked at the program, and he asked her who the woman in the Lancôme ad was. Musetta is with Alcindoro. Mimì dies.

Tadzio looks long at the beach where Aschenbach sits.

She goes again to *La Bohème*, this time with Rodolfo. They sit in the parterre. They both have a cold. She is who she was becoming. Happy from the Taittinger, she sees a shimmer of who she was the last time Mimì died.

They used to live in the building that Bob Dylan walks in front of, on a snowy day, on the record sleeve for *The Freewheelin' Bob Dylan*. (It's the one on the right, directly across the street from the blue VW camper van.) Dylan and his girlfriend, Suze Rotolo, snuggle past a white Chevy parked in front of what is now a butcher's.

*Aschenbach lifts his head, as though
in answer to Tadzio's gaze.*

She'd step outside to see a couple posing for that picture,
another friend shooting the tableau vivant. Or sometimes it
would be just one person, who would have propped a camera
or phone against a Pepsi can or something, set to self-timer
while they strolled down the middle of the street toward it.
This happened at least once a week.

The sound of poets dying in gutters. The song "Bob Dylan's Dream" is based on the folk ballad "Lady Franklin's Lament," which is about a tragic Victorian expedition to the Arctic in 1845, involving two ships, the *Erebus* and the *Terror*. In 1829, Edgar Allan Poe wrote these verses in his poem "Dream-Land": *Where an Eidolon, named NIGHT, / On a black throne reigns upright, / I have reached these lands but newly / From an ultimate dim Thule—*

The beam of a streetlight touches the hood and guides the car along until the next beam picks it up.

There are three mailboxes on the sidewalk in front of the post office. It is closed, and a couple are kissing against the first mailbox. They are kissing on the street where a different couple ran through the rain, covered by an extra-large garbage bag, late for dinner inside a museum.

Aschenbach starts to bow his head, and it falls heavily on his chest. His eyes are troubled, but his face assumes a restful expression, absorbed, as though he is sleeping soundly.

Later, the woman was angry when the man talked too long to another woman, so she began talking to a different man, and they ordered drinks. When he found her talking to the different man, the first man took the glass from her hand and drank from it.

The other woman had once waited for the man. Waited and wished, then had given up. He wished too. Now he waits.

*Down there on the sandbar, divided by an expanse of
water from the shore, it seems as though the boy smiles
and, raising his hand from his hip, indicates a distant
place on the horizon.*

There is a couple kissing against the first of three mailboxes,
in front of the post office. It is getting dark, and a woman
waits on the post office steps for a car to arrive to take her
and her daughter home.

It is on the same street where a couple once ran through the rain, late for dinner. She loved him, loved him, loved him, loved *him*.

At the dinner the man ran into a woman by whom he once was loved but whom he didn't love. He wanted to love her, but now he loves the woman with whom he ran through the rain. Now he waits for her and her daughter. Now the other woman has a son. It is getting dark, and a woman waits on the post office steps for a car to arrive to take her and her daughter home.

Despite her friends' buying her an expensive fur muff and shoving her hands into it, Mimì dies.

THE DREAM

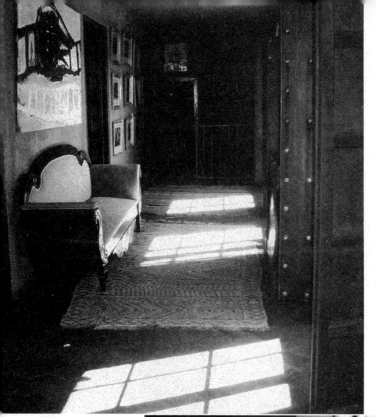

The upper passage
between the north
and south wings.

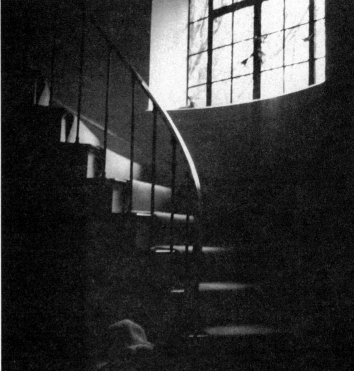

The staircase.

The kitchen, modernized in 1974.

The attic passage seen from the east staircase.

The attic passage seen from
the north-wing landing.

The first-floor passage seen from
the east landing.

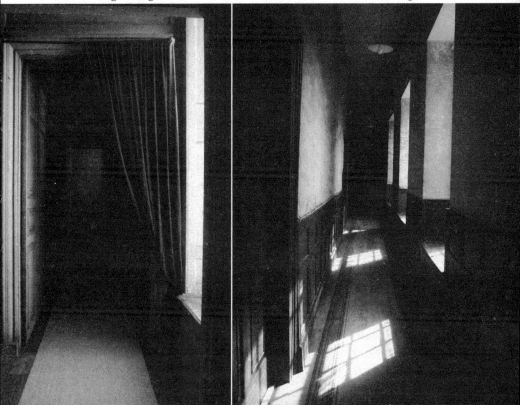

PATRICIA
LAKE

He told me twice about the visitation, once soon after it happened and then again something like thirteen years later. The first time he told me, we were outside and it was cold and I didn't listen very well. I think I thought to myself: Huh, that's weird.

The second time he told me, we were inside and we had finished our spaghetti and were drinking some red wine he had brought over, and this time I listened. I listened and heard him try to describe how, suddenly, she was there. We'd both had children by then and were not as close, and though we were lost in some ways, we were not as confused as before.

He told me that suddenly she was there and they had been talking for some time. They were in his studio apartment, and though he couldn't exactly see her, she was there and seemed to be the same age as she'd been when she died. Which was thirty-three, the age he was then, too. And they were both so lonely and they talked about how she had had babies to be less lonely and for the company and they laughed together at that. He said they just laughed and laughed. And he knew her and he liked her and he loved her.

She had died when he was ten, and most of his memories came from a film a friend of his mother's had made about her. The filmmaker was a family friend and a famous poet. Famous in Canada.

When the visitation happened, he was living on the Upper East Side and didn't see much of anyone. He drank.

He said they talked for a couple of hours. The space he lived in was small. It had a platform bed and she was there suddenly, she was impressed and happy that he was living in New York City and she said that she didn't understand how computers could be so important and how she could see bodies on the radio. Then just as suddenly she was not there anymore and he cried and cried.

BILLY BYRON

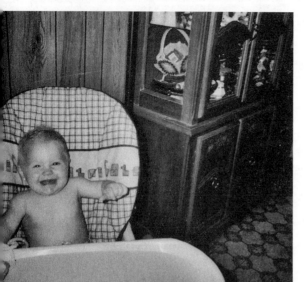

Billy Byron as a baby. He was born on February 22, 1980, in posterior position.

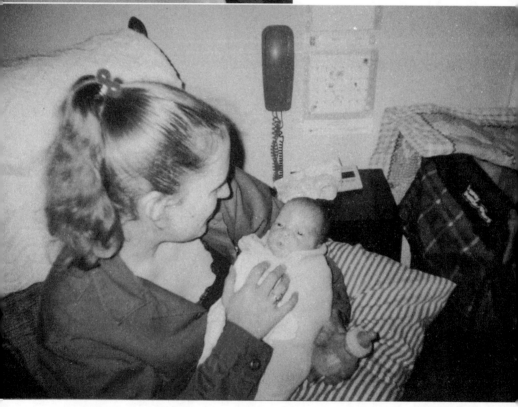

Janine Byron (née Wilmington) and Billy. Wilmington had been a national tennis champion in her youth, advancing to the semifinals at the 1977 Australian Open and to the quarterfinals of the 1978 Wimbledon Championships.

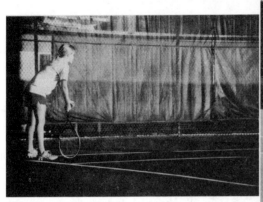

Wilmington at age thirteen.

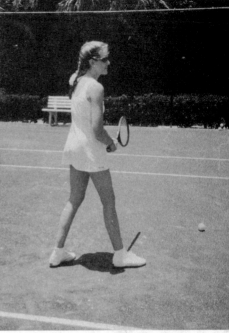

Wilmington on the practice courts at the 1975 US Open.

Ted Byron and Janine Wilmington in 1978. They married the following year. An order of restraint was issued against Byron after several incidents of domestic violence. They divorced in 1984.

As a single mother, Janine Byron raised Billy in a small house on the outskirts of Oneonta, New York.

Billy, Halloween 1985.

Billy in 1990. As a child, he displayed exceptional hand-eye coordination and a particular talent for tennis, anticipating the ball's trajectory and spin with unusual accuracy.

Billy's early drawings. Billy developed a relationship with an imaginary friend he named Walter. He would draw Walter and insisted on having two tennis rackets with him at all times, explaining that one was for Walter.

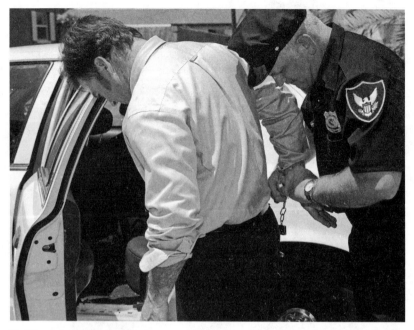

Ted Byron being led from his home in 1988. Byron was arrested on charges of stalking his ex-wife and attempted assault in the third degree.

A school photograph of Billy Byron, 1991. Billy on the practice courts, 1993.

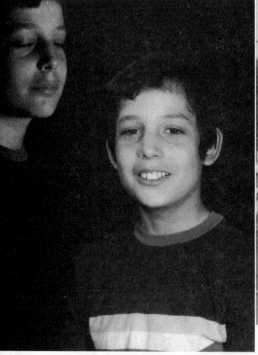

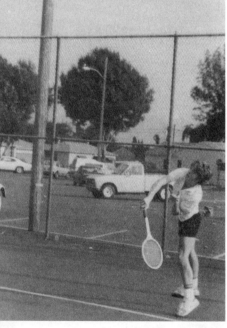

At a New York State Junior Championship in 1989, nine-year-old Billy was noticed by Ralph Jamison, who would become his coach for the next eight years.

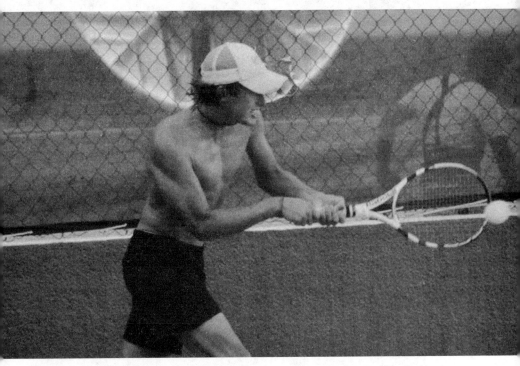

Billy Byron in 1996. Under Jamison's tutelage, Byron rose to become the second-ranked junior player in the country. Jamison remarked that Byron's potential was enormous, and that the boy seemed to have an uncanny sense for where the ball was going.

In 1997, the year Byron became the top-ranked junior in the country, Ralph Jamison died in a car crash. A devastated Byron moved to Florida to train at Nick Bolletieri's Tennis Academy. Years later, Byron's mother recalled that just weeks before the crash, Jamison revealed to her that on his first meeting Billy, the boy had said to him, "Walter tells me where the ball will go."

Byron in 1998. His game came to be defined by a frustrating but effective style: competent yet unremarkable serves, and rallies that would last until the moment his opponent seemed poised to take the set. The stress of deuce, set, and match points inspired Byron's best playing.

After victorious matches, Byron would suffer from long periods of anxiety and fatigue. These spells prompted the press to dub him "Blue Byron."

Byron after his 1999 Marquis Open victory.

As Byron continued to win, reports of his erratic on-court behavior increased. He was observed to speak audibly before serves and points, as if to an unseen other, and to shake his head and laugh.

In 2000, Byron held a press conference to challenge an opponent's accusations of courtside coaching. Number four–seeded Owen Oberman, Byron's longtime rival, had accused him of cheating, claiming he had heard him "talking to someone" in the men's locker room before a quarterfinals match at the Rogers Cup. Byron denied being coached but admitted he talked to himself when he needed "psyching up."

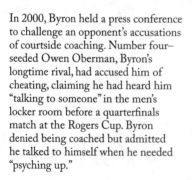

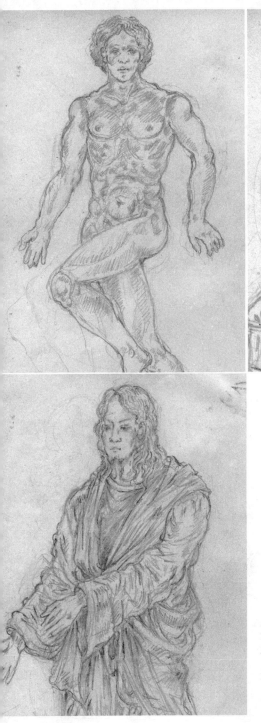

Drawings from Byron's sketchbook, 2000.
Byron was self-taught and often sketched
between matches. His books were filled with
images of a figure wearing nineteenth-century
North African dress. Byron often wrote the
name "Walter" alongside these drawings.

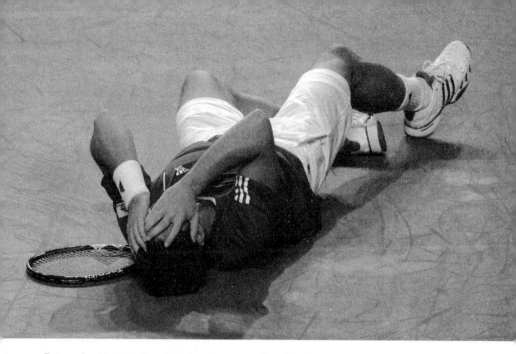

Byron after his 2001 Omega Open victory over Peter Evanston.

Byron after his 2002 Indian Wells victory over Henry Klinger.

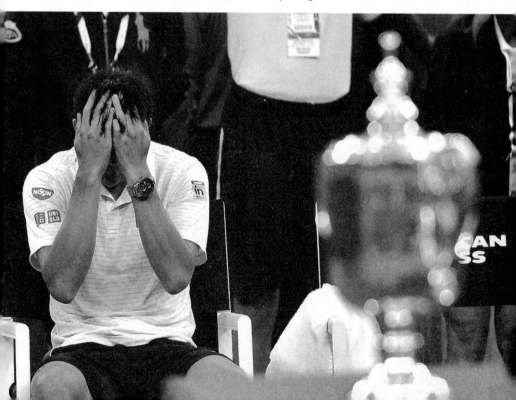

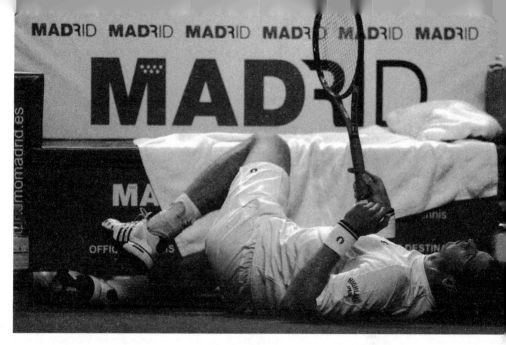

Byron after his 2003 Madrid Open victory over Buzz Klein.

Minutes after his 2003 US Open victory over Ian Maitland, Byron fell into a coma.
Janine took her son for evaluation with Dr. Fran Lebvol at the University of Western Ontario.

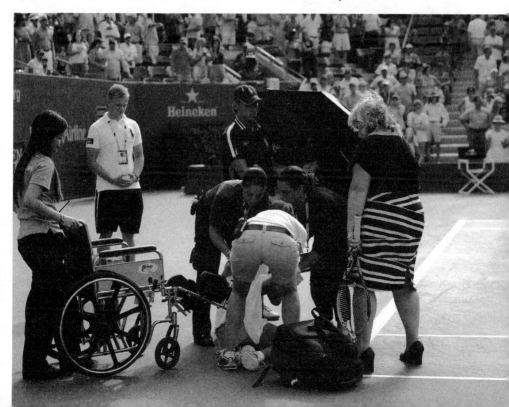

Dr. Fran Lebvol was a pioneering researcher in the field of bicameral psychology, with a focus on sensed presence. Sensed presence refers to the experiences of explorers, sailors, POWs, survivors of shipwrecks and terrorist attacks, and other sufferers of extreme trauma who have reported becoming aware, in grave situations, of an unexplained presence having joined them, a benevolent companion or helper.

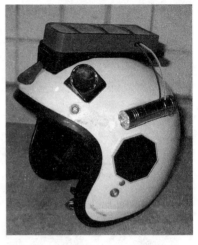

Dr. Lebvol's Bicameral Sense Helmet, designed to stimulate the angular gyrus through magnetic waves. The stimulus causes the wearer to sense a presence, usually described as behind and to the right of the subject.

The many people who have felt a sensed presence include Ernest Shackleton and Charles Lindbergh, both of whom recorded the experiences in their published accounts. Shackleton, in describing his famous journey with Tom Crean and Frank Worsley over South Georgia Island, noted that "during that long and wracking march of thirty-six hours over the unnamed mountains and glaciers of South Georgia it seemed to me often that we were four, not three."

On his first solo transatlantic flight from New York to Paris, Lindbergh recalled, he fell asleep, and woke to the company of "presences—vaguely outlined forms, transparent, moving, riding weightless with me in the plane. . . . Without turning my head, I see them as clearly as though in my normal field of vision." He wrote that they were "giving me messages of importance unattainable in ordinary life."

Within a few months of observation, Lebvol succeeded in pinpointing Walter's appearances in Byron's consciousness to his "threshold" moment of life-threatening exertion during his matches. Byron admitted that this was "what it takes for me to win."

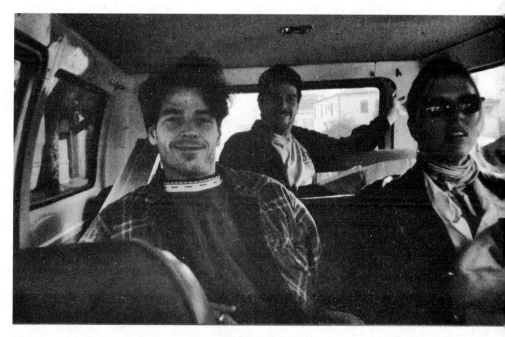

Byron took a leave of absence from the sport in the fall of 2004, spending time with friends and continuing to see Lebvol. But after four months he fell into a severe depression. Within a year he had returned to the game.

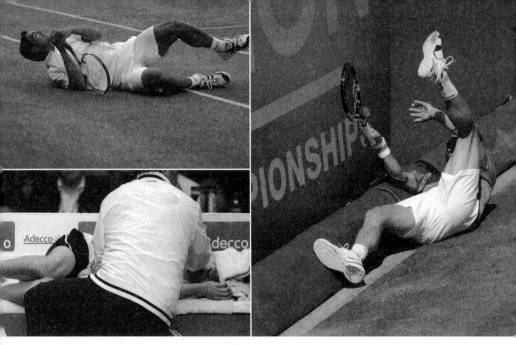

Byron's game continued to follow the familiar pattern of victory and collapse. Crowds were drawn more by the spectacle of his breakdowns than by the play. They started arriving after the first and second sets. USTA officials began to fear for his stability and health. It had become clear to Lebvol that Walter's presence was not entirely benevolent. Walter helped Byron win, but could do so only when Byron drove himself to injury and exhaustion.

After a fall left Byron with a broken leg in 2005, the USTA made the unusual decision to suspend him, citing concerns for his health.

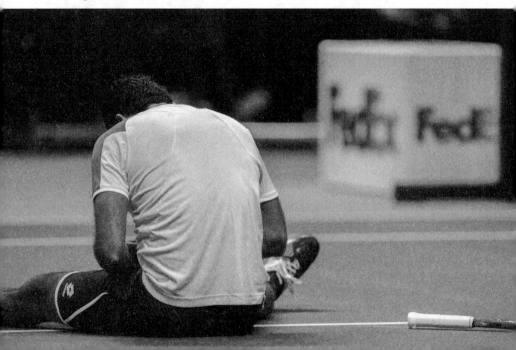

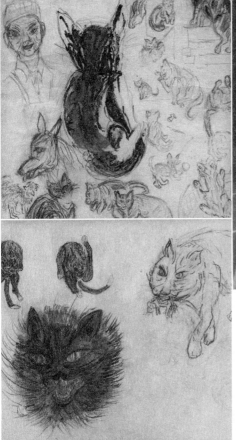

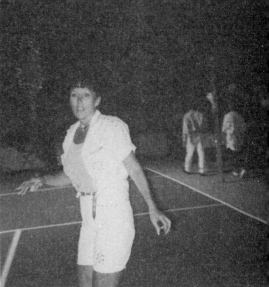

Janine Byron at an exhibition tournament in Lisbon in 2001. Out of concern for her son's sanity, she made plans to move with him to the Southwest, in order to be closer to her family.

Shortly after his suspension, Byron suffered a complete mental breakdown. He moved back in with his mother and spent another stretch of time in Lebvol's care. He sketched constantly, his drawings growing darker in content. Byron complained of missing Walter, insisting that he had "let him down."

On the day of the planned move to the Southwest, Billy Byron was reported missing. Two days later, a set of his tennis whites were found folded neatly on a rock in a ravine behind his mother's house.

PUBLIC FIGURE
BEAUTY LOVER
DIGITAL TALENT
TRAVELER
SPINARIO
PARMA/ABU DHABI

So beautiful.

I love.

That looks relly relaxing.

Where can I find that dress?!

Love this dress babe.

Hi my love.

Looks like you're having a great time!

Wow so stunning.

Beautiful shot and dress.

How stunning are you.

Is that a skirt or dress? Love the lace.

Wow.

My dear, so elegant, so confident, I'm in love with your feed.

So beautiful.

Oh wow looks so dreamy.

Such a lovely picture girl.

Love your dress so gorgeous.

Wow so beautiful.

Gorgeous dress and gorgeous photo.

Lovly dress!

Ahhh I love this looks amazing.

This shot is so beautiful of you.

What a lovely room.

Oh wow enjoy it.

Love this stunning dress!

This is romantic.

Looks wonderful place there.

This is beautiful.

Such a wonderful pic.

This is goals.

AT THE FOOT
OF THE BED

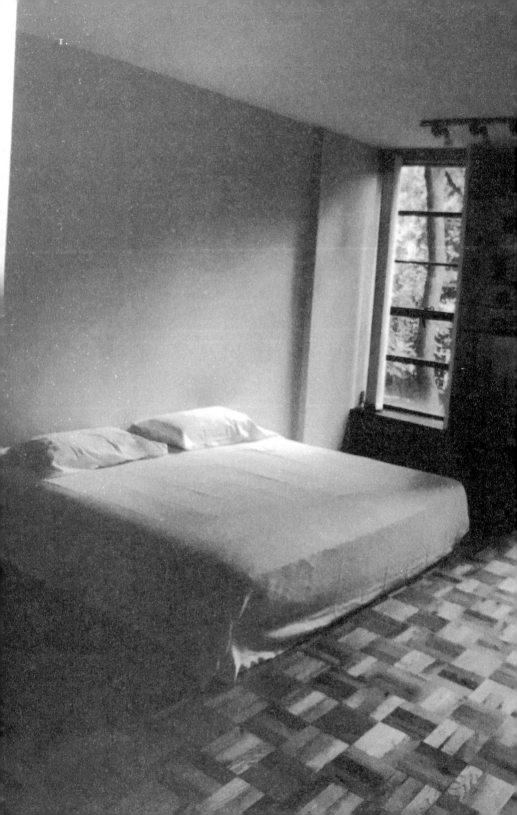

I.

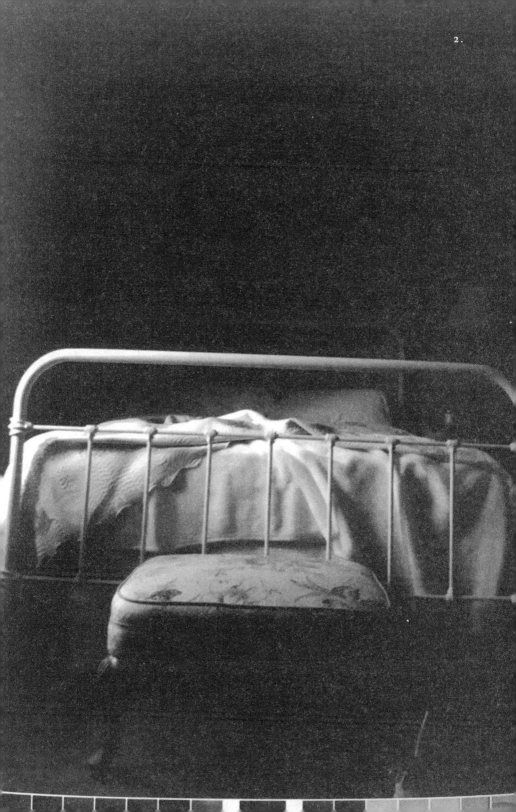

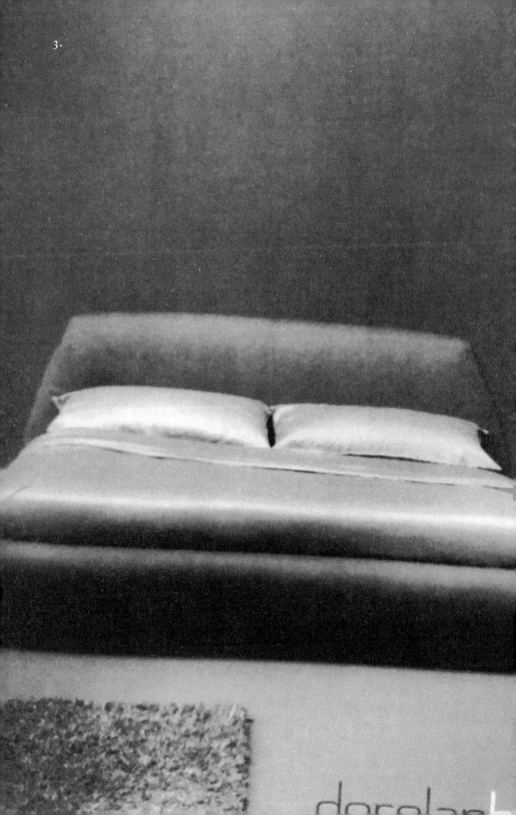

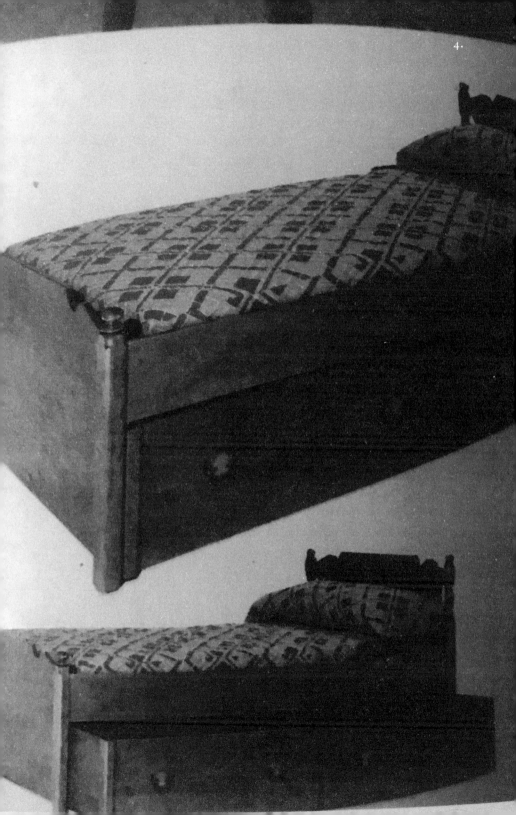

4.

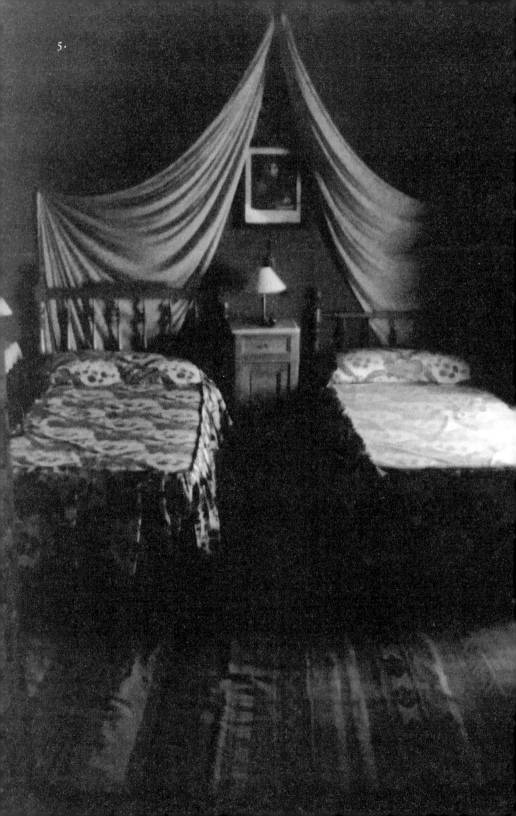

7.

n House of Margaret, Duche

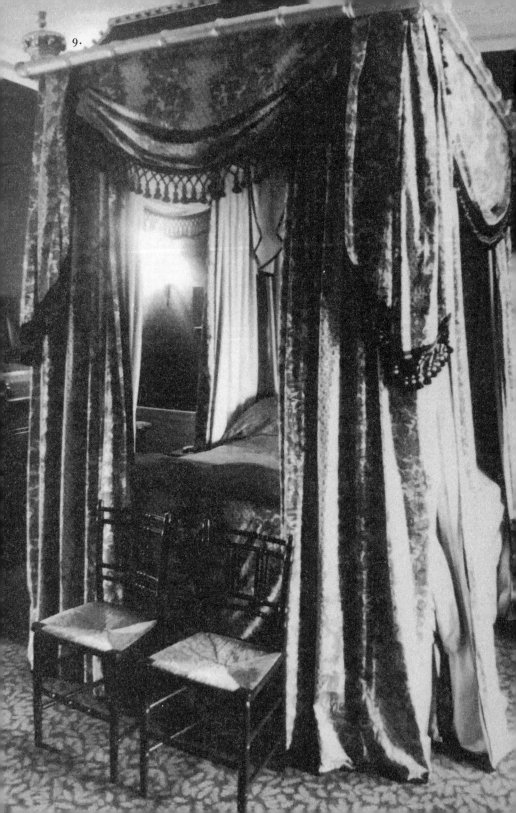

ena in Natural Oak

EW BROCHURE | FREE DESIGN PLANNI

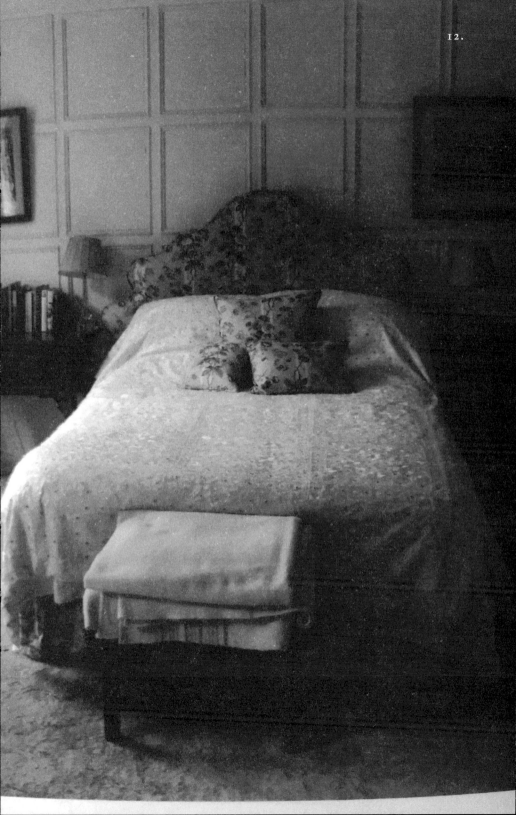

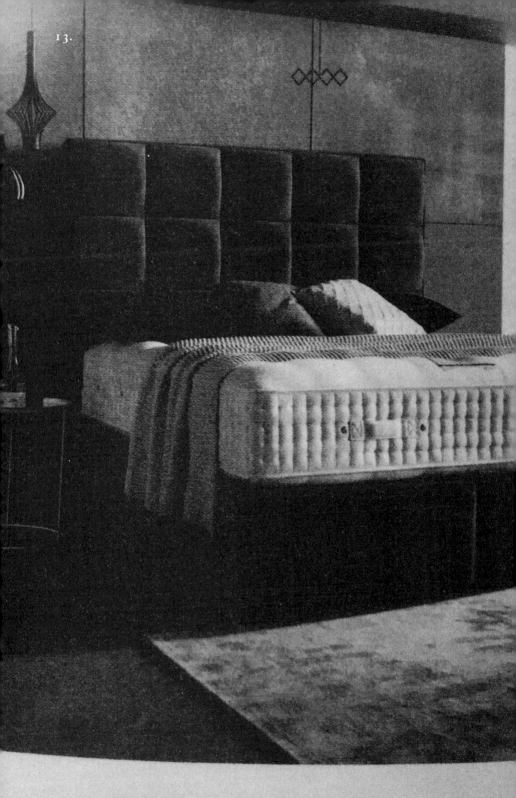

13.

FOR SOME SLEEP IS

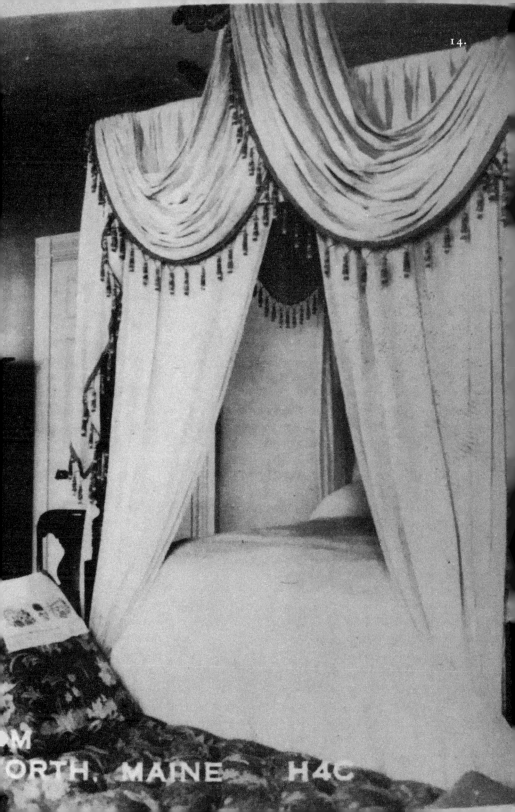

14.

ORTH, MAINE H40

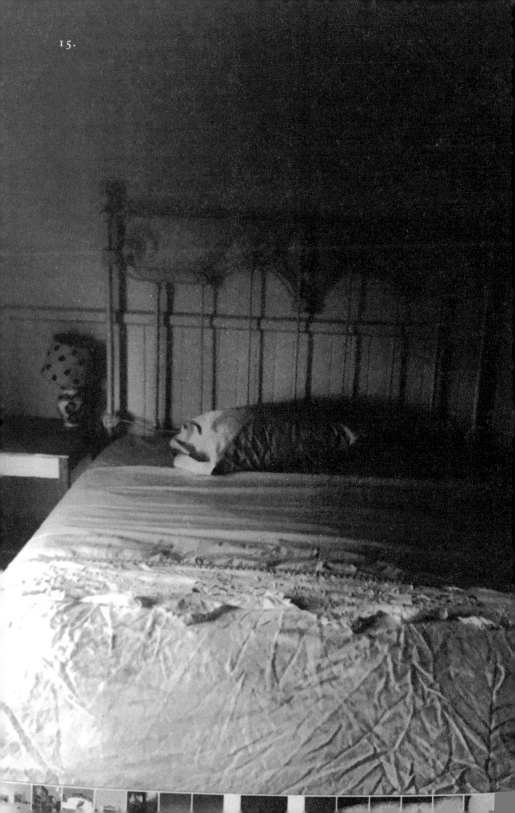

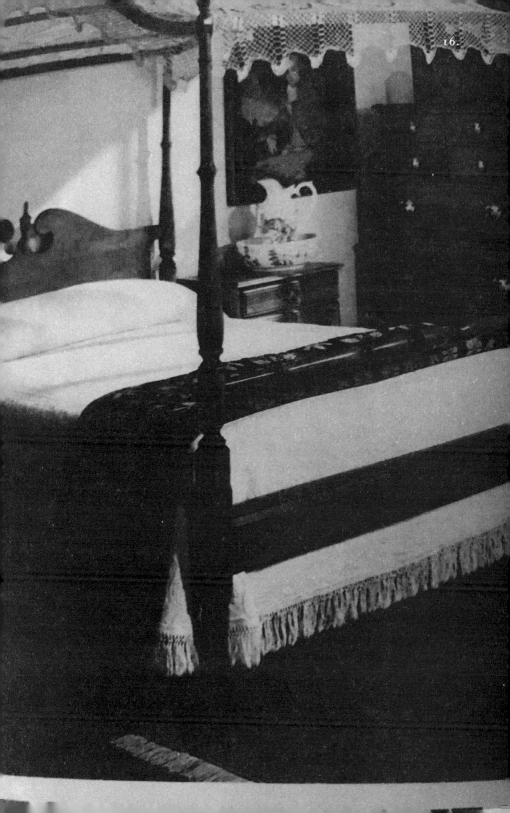

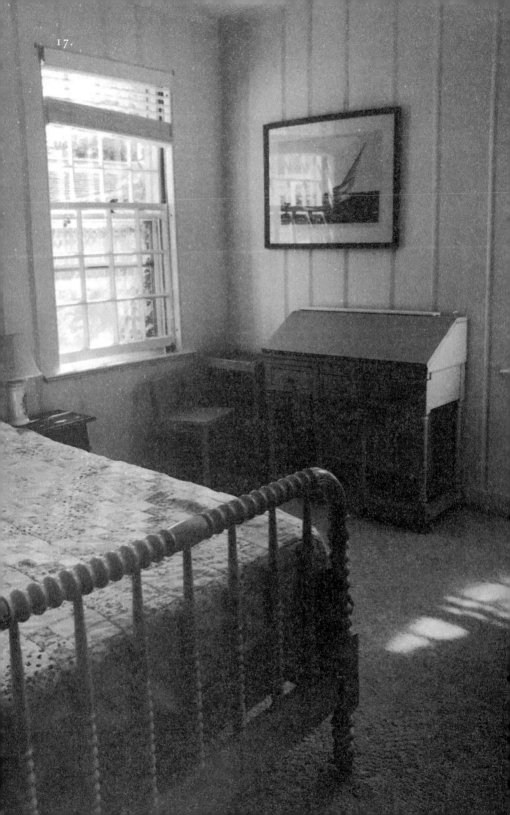

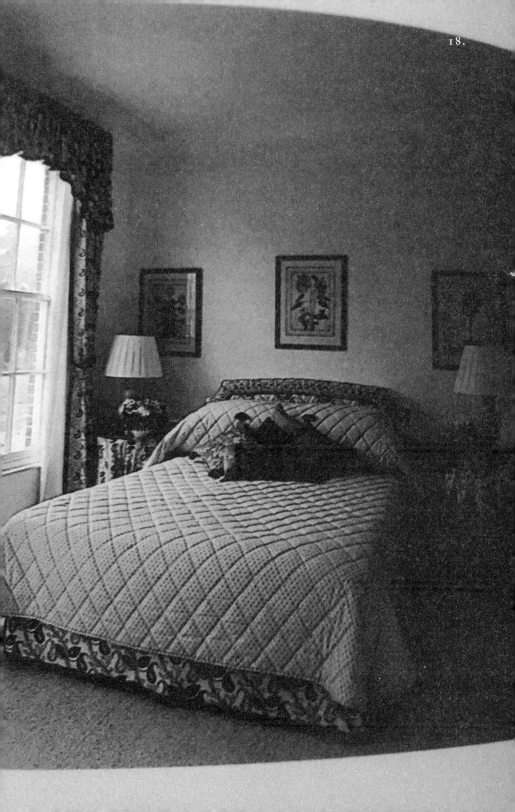

1. She was given a room to stay in. She woke up, and there was a man in a green cardigan at the foot of the bed. He looked surprised to see her. Then he disappeared.

2. His wife had a dream. There was a female figure at the foot of the bed. She tried to talk to it. She asked, "What do you want?" In the corner of the room, a terra-cotta urn fell to the floor and smashed. She asked again, "What do you want?" The figure handed her a letter, and his wife knew it held news about their children.

3. He just stood at the foot of the bed. He could not believe there was someone in it. He was angry that he could not climb in and fall asleep, and he was cold and confused.

4. The owl flew in a silent circle around the room, landing on a post at the foot of the bed.

5. She watched her, wishing she would wake up, wishing she could get in beside her and then she would wake up, why was she not waking up? She was going to wait until she woke up. She was going to stay right there until she woke up again.

6. The woman in the bed was the same age as she was. The woman in the bed had been able to have children. She was jealous that she had children.

7. There were three children sleeping in the bed where before there had been two.

8. His blankets were pulled violently off. At the foot of the bed he saw a dark figure that abruptly vanished when he addressed it.

9. The man's face was clean-shaven, and his hair was cut short as though he were sick. He was bare-chested even though the room was always cold. The bed was in the same place.

10. The woman at the foot of the bed stood still. She had no features, but she had a lot of lace on her head.

11. She saw a figure bent over one end of the bed, whispering in a foreign language.

12. She woke when she felt something heavy settle itself down on the blankets at her feet.

13. When she looked at the picture of the bedroom, there was a figure beneath the covers.

14. The bed was curtained and canopied. Suddenly the curtains at the foot of the bed were drawn back and he could make out the shape of a great cat, a panther perhaps. With its eyes fixed upon him, it slowly began to approach the foot of the bed. It made its way around to the left side of the bed.

15. They were awakened by a strange noise. A calf stood in the center of the room. It approached them and placed its forelegs on the foot of the bed.

16. The armchair moved by itself across the carpet and stopped at the foot of the bed.

17. The figure at the foot of the bed was nude and emitted a bluish-white light.

18. When he woke and looked at the spot where he'd seen the figure in the night, there was a small ringlike burn on the carpet.

I WILL DRAW
A DIAGRAM OF HER
MOVEMENTS

will draw a diagra.

I'M HIDING. VERY MUCH HIDING. She is shameless. My blood pressure may be low, but she is shameless. I'm hiding from her so she doesn't see what I do next. So she doesn't meet my friends and ask me for their numbers or email addresses or handles or anything. So she doesn't see me anymore. Or see what I do. So she can't copy. Her versions of me. Her twins. I'm hiding in here, out of sight. So she can't get me, can't copy me and twin me. It's not okay. She's made copies of him, copies of my supplies, of my phone book. Once she outright stole and sold it.

of her movements:

DOOR

WINDOW

The creepy creeping. The okayness creeps. I hear from friends. I can eat almonds in here and she can't see me. I'm very much hiding. Coincidence. A twin grew beside her and then kept growing, kept finding tissue to absorb and duplicate. Twins want to twin. What moisturizer. What shoes. She wants my bathing suit. I'm hiding.

There is a corridor at the top of this house; it's long and passes a number of rooms. In the middle of the corridor, the passage opens onto a larger room where there are people. It is essential I pass this part as quickly as possible.

CHRISTMAS EVE

Nuts, Swiffer handle, Puff pastry, Oranges, Spoon, Eggs, White chocolate, Milk
The night before, the twenty-third, at a party, the subject of ghosts came up. She asked the Academy Award winner if he believed in ghosts or if he had a ghost story. He shook his head, sat down, and began talking to someone else. It occurred to her that maybe the subject of ghosts was not cocktail party conversation, and that the stories that could be told over canapés were not the only ones. There were other stories that were harder, impossible, to tell.

Later, on the walk home, her friend elaborated: A suicide, an infanticide. Ghosts. Not ghost stories.

She slept alone that night. Her daughter was with her father. Woke at five, took a sleeping pill, and then woke at nine. It was raining out. It was Christmas Eve. The tasks of the day felt like brushing crumbs from a countertop. The vinegar in her salad at lunch was strong, everything stung, her tongue felt burnt.

There was a service at the church. Her neighbor recognized her, her ex, and her daughter and invited them over for eggnog and cookies. Why not? Why not. The apartment, with the neighbor, her children, and her grandchildren, felt warm. They ate crackers out of the package and cheese and whatever was in the fridge. There was turkey chili for the kids and some champagne. For the moment she got the Christmas feeling, that everything was right.

As they drank the champagne, the subject of ghosts came up. A ghost that had haunted an ex-fiancée, a blur in the air that circled the bed. A cold wind that had come down a chimney into a large stone fireplace, drawing the pregnant woman toward it. The ghost of an actor's father. They left. She and her ex-husband put their daughter to bed. Her ex-husband was sleeping over at her apartment so the family could be together on Christmas morning. She left them together reading books.

Finally, at the last party of the night, in a house by the river, she told a story to a couple about meeting a librarian earlier in the week. She had just lost her husband and was not taking part in preparing dishes of vegetables and cheese for the library staff Christmas party. Grief came off her like heat.

It was getting late. She left and walked east, away from the water. She wanted to walk and walk and keep walking.

When she got home her sweater itched, so she stripped down to hose and bra and tidied up.

She went into the bedroom to get her nightgown and saw her husband's body in her bed. She heard him breathing.

PEELE HOUSE

Peele House was built in 1931, in Deacon's Hamlet, New York, by the Herfleisher and Peele families. It was a hunting lodge for the Peele family for a number of years, before being converted to a residence in 1950.

The stairwell window seen from the lawn, before the 1962 renovations.

Deacon's Pond.

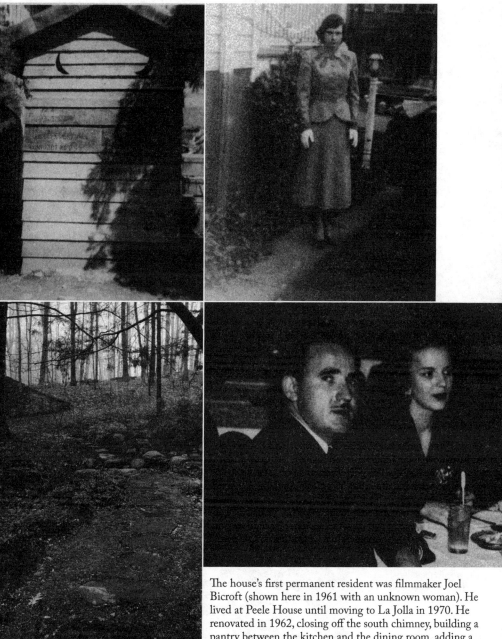

e of the old outhouses. An Edwardian
och was found here in 2006.

Mae Richfield, a resident of Deacon's Hamlet, who
suffered five miscarriages between 1937 and 1942.

On the left, a storage hutch on the
property, built into the side of a hill.

The house's first permanent resident was filmmaker Joel
Bicroft (shown here in 1961 with an unknown woman). He
lived at Peele House until moving to La Jolla in 1970. He
renovated in 1962, closing off the south chimney, building a
pantry between the kitchen and the dining room, adding a
new entrance, and modernizing the kitchen. He lived in an
unconventional arrangement with two female companions,
Angela Creswell and Keira Henderson.

A still from *Encounter à Deux*, a 1964 Joel Bicroft film.

The pantry between the kitchen and the dining room. A fireplace was blocked off to create this passage.

Kimberly Cass, an actress who lived in the house with Bicroft, Creswell, and Henderson in 1968. Cass confided to a friend that she felt uncomfortable in the house and would often encounter the scent of violets in the pantry.

Keira Henderson in 1960. Henderson suffered a miscarriage in 1961 while living at Peele House. She later gave birth to a son, Jonathan Bicroft. As an infant, he slept in a dresser drawer in her bedroom.

Angela Creswell. She stayed in the Deacon's Hamlet area after Bicroft, Henderson, and their son moved to La Jolla. She later married and would refer to Peele House as "the sad house" to friends.

The dining room.

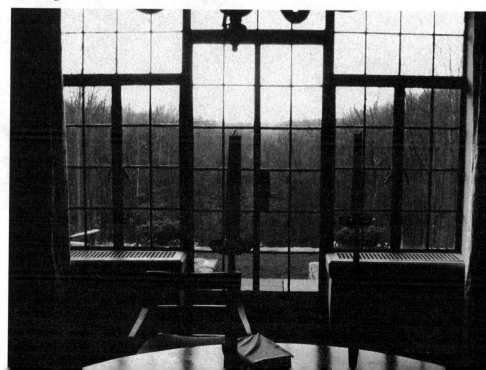

The Howe family in May 1972. The family added two small rooms above the garage when they moved into Peele House in 1970.

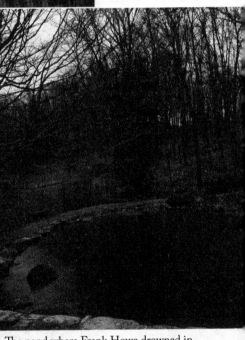

The pond where Frank Howe drowned in August 1972.

Peele house was untenanted from 1975 to 1979, when Chester and Grace Keane moved in, with their son, Francis, shown here as a baby.

Francis Keane on his third birthday.

The Keanes' German shepherd, who would often bark at the southwest corner of the dining room when nothing was there.

The master bedroom during the Keanes' tenancy. Grace Keane remarked that the room had faulty wiring and the lights would flicker erratically.

The ravine directly below the house, where Grace Keane would hear the sound of children playing.

The guest room bath, located next to the disused chimney.

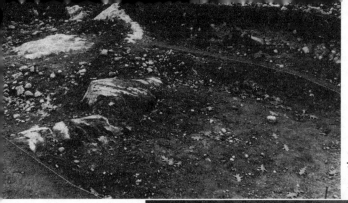

Jacob and Raymond Dance bought the house in 1985 and installed a swimming pool.

The room above the garage where dramatic fluctuations in temperature were observed.

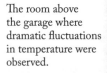

The living room, where a puddle of water would appear in front of the large window.

QUESADILLA

THERE IS A HOUSE ON THE SHORE OF INCHIQUIN LOUGH. The house was the home of the Leighton family from the late eighteenth century until the late 1870s, when it became the residence of Lieutenant Colonel John Bridges.

When the couple visited, it was a bed-and-breakfast. It had a green-painted entrance hall, high and bright, with six white doors leading from it. An oak fireplace sat dark in the daylight. A yellow-handled broom and a plastic bucket stood beside a rectory chair.

Beyond the hall, the rooms were prettily wallpapered, and objects were placed on dusted tables throughout the house.

Along the red-carpeted upstairs passage, rows of Penguin paperbacks were organized by color along low shelves.

In the middle of the night, the woman got out of bed and stood at the window overlooking the lawn. There was a circle of stones in the grass, grass that looked blue in the moonlight. She used the toilet and then sat in a chair opposite the bed in her pajamas. Her husband snored lightly, and she watched him in the grainy dark.

The first time the couple traveled together, he had told her he loved her as they sipped rum punch and waited for their bags to be picked up in front of the resort. She felt so warm—the tropical island, the tropical drink, the unexpected declaration. Back in New York, at the baggage claim, he stood ten feet in front of her, arms crossed, waiting for their luggage. He could have been by himself. She had a feeling of being deeply ignored. She felt more alone than she had in years. A sadness came over her then, a dawning.

Over time she came to love the freedom his indifference provided. She felt it gave her liberties of body and heart. She could love not being seen, got used to it, to not being asked anything of herself in return. She came to see her own neediness as lack of freedom. The fights happened when this ice cracked.

They left Ireland. When they got home, he made them each a quesadilla.

He ate his. While she unpacked, he absentmindedly ate hers too. An hour later, when she returned for her quesadilla, she saw he had eaten it. When she asked him why, he flew into a rage.

GYMNOPÉDIES

12 MARCH 2017 [NIGHT] *Barricading bedroom door from inside.*

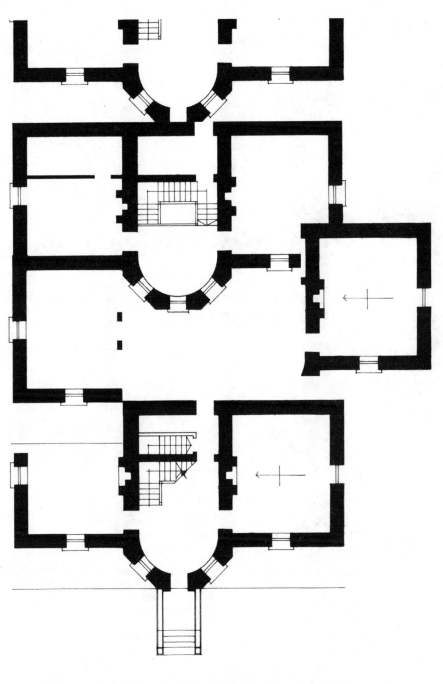

13 June 2017 [Night] *Refusing to bathe.*

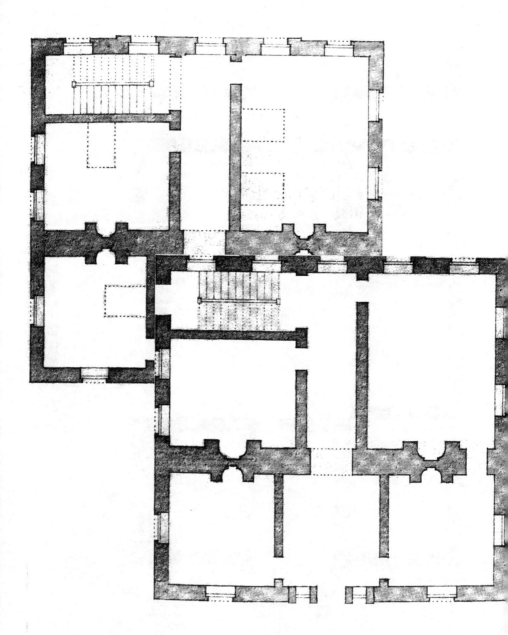

25 JUNE 2017 [NIGHT] *Asking where everyone is, including her deceased siblings.*

19 July 2017 [Day] *Rearranging her things repeatedly.*

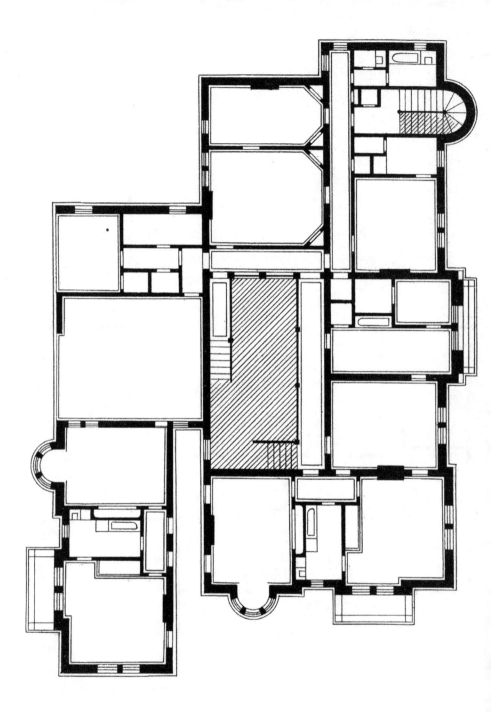

20 July 2017 [Night] *Afraid to sleep because of fear of not waking up.*

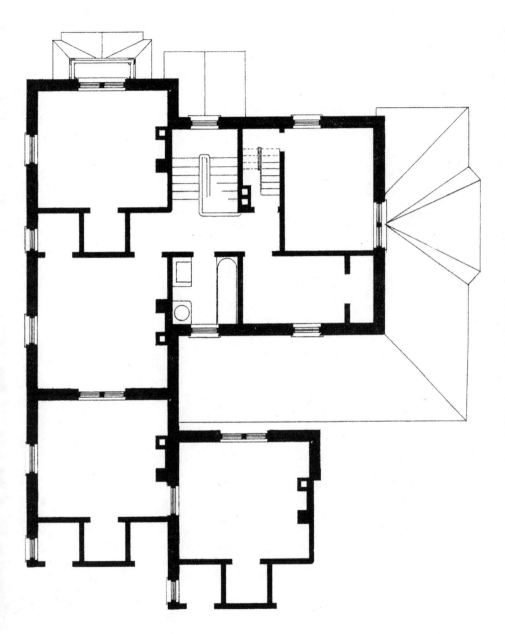

21 July 2017 [Midnight] *Calling for "Inay" ("Mother" in Tagalog).*

VIDEO

It was a warm night in early September. The occasion was a four-course dinner and fashion show. The guests mingled in the museum garden, drinking champagne. Two society photographers took pictures of women in their dresses, heads pressed together, and couples, inanimate as they posed. There were seven guests at my table: a playwright, two actors, a director, a producer, a journalist, and me. As the meal progressed, the table began to trade stories, each person speaking in turn while the others listened. One of the actors described a bitter but wisely unsent email. The other recounted a subway ride. The journalist reacted to the day's news, and the playwright described an uneasy silence. Finally the director told a story.

Her friend was apartment- and dog-sitting for a couple. One night, from the front room, her friend called the couple's three dogs. She took a video of them running down the hall to her. The director paused, then described the video.

She said it began with an empty hall, with two doors visible at the far end. The three dogs were then seen coming down the corridor, their hindquarters wagging. Behind the dogs, a dark figure moved swiftly from one side of the hall to the other.

The director told us that when her friend saw the figure, she called the police. When they arrived, she showed them the video, but they left without finding anything.

The director had a copy of the video on her phone, which she pulled from her purse. She held the screen for the producer, one of the actors, and me to see. It was exactly as she had described. I gasped when I saw the figure. The opposite side of the table laughed. Then the director showed it to the other actor, who groaned, eyes wide, at the moment she saw the figure. Finally the video was replayed for the playwright and the journalist. The playwright's hand flew up to cover her mouth.

MIDDLE DISTANCE

Wall Type Mirror

I'm at my best at middle distance, he told the psychotherapist. I'm not good with intimacy. He wanted to stretch out on the couch, like in analysis, but she was looking at him from her chair and it was their first meeting and so he didn't. He felt his phone vibrate in his breast pocket. As his right arm darted across his body to reach inside his jacket, he stopped it and instead put his hand on his knee.

BEVELED EDGE Venetian Style — ½"

I'm not very good at physical affection, he said to her. She wrote something down.

560 L, 570 L, 580 L—With Lights

As he left her office afterward, he thought to himself: Where can I get a salami sandwich and a coffee? He didn't know this part of town. He wanted one of those fancy prepared-food stores with refrigerated rows of creamy salads, sliced squares of lasagna, and stacks of frosted baked goods.

MADE TO HANG
TWO WAYS

SQUARE MIRRORS—Made to hang 2 ways—Square or Diamond

When he arrived home that afternoon, the light in the apartment was bright and warm. The living room had been tidied by his cleaner. There was a paper towel on the glass coffee table but he ignored it. He walked over to the couch and laid his body the length of it, keeping his shoes on. I'm lonely, he said aloud. Then he said: No, I'm not.

LSE 362-B

He closed his eyes and thought of his last therapist. His last therapist had pointed out that he never used the word "we" when talking about his ex-wife. That was when he had decided not to go back. When he decided his therapist sounded like his ex-wife. He didn't miss her, or his last therapist, in the least. He liked being alone. Not having witnesses.

He sat up and rubbed his eyes with his palms. He reached for the phone in his breast pocket to look at a number of pictures he'd taken of himself the night before.

He deleted them all.

A GEIST

FRIDAY, NOVEMBER 2, 2018
Bhanurekha Singh, Kyle Frank, Edward Mintz, Lilly Bock
Private dinner for Lucien Pak at Terro New York, hosted by
Bénédicte Orrin

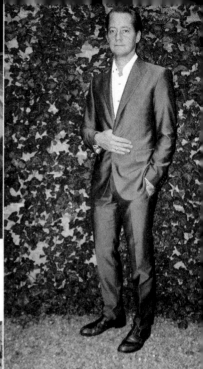

FRIDAY, NOVEMBER 2, 2018
Edward Mintz
Kapitan Vodka celebrates the
release of "Alone, Forgetting"
at Film Center

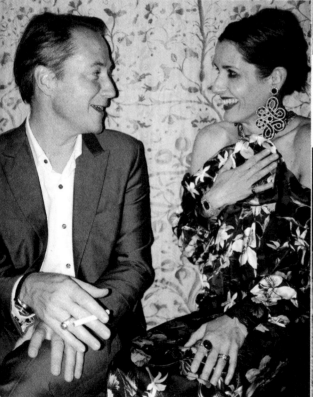

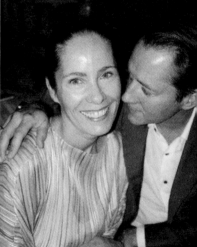

FRIDAY, NOVEMBER 2, 2018
Edward Mintz, Catherine Crittendesh
Preen Crystal presents a listening party for new
Petra Weiss album "Portofino" at Conclubina

FRIDAY, NOVEMBER 2, 2018
Trina Beller, Edward Mintz
Modern Royale launch at Palmer

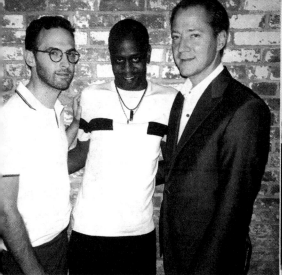

FRIDAY, NOVEMBER 2, 2018
Matteo Finzi, Percy Mills, Edward Mintz
Dinner for Percy Mills
at Cumberland Inn on the Hudson,
hosted by Steven Gerebain and Lucy Dehaviland

FRIDAY, NOVEMBER 2, 2018
Edward Mintz, Lady Kimberly Gough
Strictly Flora fragrance launch,
hosted by Stornoway Brut at Lucky's

FRIDAY, NOVEMBER 2, 2018
Edward Mintz, Felipe Gutiérrez, Leandro Andrade
Croix d'Espagne dinner for Pablo Castavets,
hosted by the Spanish Cultural Council

DAY, NOVEMBER 2, 2018
arion Key-Harris, Edward Mintz
ndy Krug toasts Petal's new brand director
arion Key-Harris at Omni New York

FRIDAY, NOVEMBER 2, 2018
Ben Joplin, Edward Mintz
*Dinner for Pabrul Kes at Viz, hosted by
Natalya and Mika Yvonerovitch*

(ABOVE) **FRIDAY,
NOVEMBER 2, 2018**
Chloe Cwoniak,
Edward Mintz, Ed Y
*Book signing by Rix D
at Le Bookstore*

**FRIDAY, NOVEMBER
2018**
Edward Mintz
*Benefit cocktails for pa
of Cawthra Reservoir
at The Riley Museum*

FRIDAY, NOVEMBER 2, 2018
Edward Mintz, Valentina Kroop
*Laskina celebrates its tenth
anniversary at Lake Michigan*

FRIDAY, NOVEMBER 2, 2018
Kirsten Mulrooney, Edward Mintz
Cocktails for Catatonia Pre-Fall at Chocolat

FRIDAY, NOVEMBER 2, 2018
Edward Mintz, Pico
Lendt, WHO AM I?
Halloween party for
Sick Children's Hospital
at Kleinburg Hall

(BELOW) FRIDAY,
NOVEMBER 2, 2018
Sally Mecklespooner,
Edward Mintz, Tim Klein
Dinner and auction for
Deppler Farm at Juno

(RIGHT) FRIDAY,
NOVEMBER 2, 2018
Leonora Zimmerman,
Edward Mintz
Manuela Rico hosts
cocktail party for NYC
Psoriasis Association
at Leopold

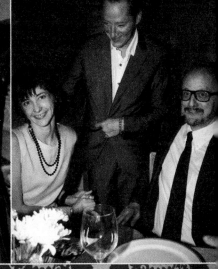

(BELOW) FRIDAY,
NOVEMBER 2, 2018
Jimmy Lotto,
Edward Mintz
Post-show party for
"Lordy, Lordy"
at the Majestic

(RIGHT) FRIDAY, NOVEMBER 2, 2018
Edward Mintz, Peter Sharp
"Duck" magazine after-party
at Barisotto, LA

FRIDAY, NOVEMBER 2, 2018
Sonja Kettle, Edward Mintz, Greta Diaz
The editors of "Loon" celebrate "Margins"
by Ponyo Ayelowu at Club Bernishcke

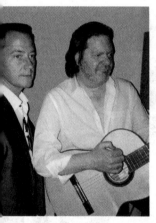

FRIDAY, NOVEMBER 2, 2018
Edward Mintz,
Allerton Heath
Launch for Osset
Black Label
at the offices
of Lamb Surplus

FRIDAY, NOVEMBER 2, 2018
Rivera Gibbon-Jones, Edward Mintz
After-party for J. M. Mugford performance,
hosted by Wendy Margaret Brown and John Sirk

(BELOW) FRIDAY, NOVEMBER 2, 2018
Benno Crespo, Edward Mintz
Drinks for Leighton Parrish
at Club Grange

FRIDAY, NOVEMBER 2, 2018
Ada Wetherby, Edward Mintz, Binty Brahm, Liz Saville
Private screening of "Mill House Posset"
at the home of Suzan Moore

FRIDAY, NOVEMBER 2, 2018
Edward Mintz, Edie Bachelor
Listening party for Mojito at Flume

FRIDAY, NOVEMBER 2, 2018
Lorrie Booth, Edward Mintz, Ciara Booth
Celebrating the new Kendrick pop-up bar

FRIDAY, NOVEMBER 2, 2018
Edward Mintz
Sachs-Corber X Cola launch party at Illegal

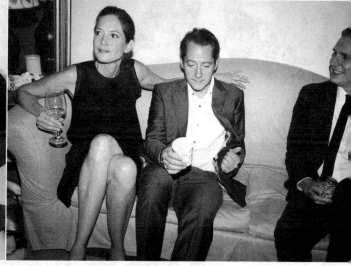

FRIDAY, NOVEMBER 2, 2018
Edward Mintz, Jake Peretz
Panel discussion of "Criterion Meridian" at Gallery Medusa

FRIDAY, NOVEMBER 2, 2018
Joan Gunn, Edward Mintz, Owen von Richtenbach
Reading and discussion of "Causeth Sath" by Ken Ao, hosted by Icecrush and Firstjet Air

FRIDAY, NOVEMBER 2, 2018
Edward Mintz, Szilvána Asta
Intimate 50th birthday dinner for
Harry Asta, hosted by Bobo Spumanti at
Trattoria Naranzaria

(LEFT) **FRIDAY,**
NOVEMBER 2, 2018
Edward Mintz, Jedediah Bismarck
Charity auction for Pets in Need
at Dorfenhagen Biergarten

(BELOW) **FRIDAY, NOVEMBER 2, 2018**
Edward Mintz
Arrivals for BFQA Awards at Durham Hall

FRIDAY, NOVEMBER 2, 2018
Veronica Latimer, Edward Mintz
Garden party in honor of Annabelle Latimer's
third book of poetry, "L.A. Turmeric"

(RIGHT) FRIDAY, NOVEMBER 2, 2018
Edward Mintz, Jerome Oka
Pre-concert reception for T-cox at Eugene's on the Park

(LEFT) FRIDAY, NOVEMBER 2, 2018
Edward Mintz
Mickey X Roobois pop-up launch party

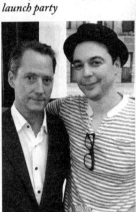

FRIDAY, NOVEMBER 2, 2018
Edward Mintz, Conrad Lord
After-party for "Coming of Age" at Columbia Gatehouse

RIDAY, NOVEMBER 2, 2018
lan Staniland-Lenton, Marie Greggs, Edward Mintz
rivate dinner honoring Joyce Silvester

FRIDAY, NOVEMBER 2, 2018
Dr. James Olroyd, Edward Mintz
Book launch and signing for "Indefensible" by Sophie Dench

FRIDAY, NOVEMBER 2, 2018
Sonny Smyth, Edward Mintz
Reception for Sonny Smyth at the residence
of Christoph and Anna Marcus

FRIDAY, NOVEMBER 2, 2018
Edward Mintz, Jane Whittaker, WHO
AM I?, Jermaine King
Rooftop premiere of "Creamer ii" by
Jermaine King, hosted by Trefoil Pictures

FRIDAY, NOVEMBER 2, 2018
Edward Mintz, Teddy Quinn
Backstage reception for Decoder private listening party
at Hotbox

FRIDAY, NOVEMBER 2, 2018
Edward Mintz, Erich Holzer
Red-carpet arrivals for "Belle Matinée"
at Alice Tully Hall

(RIGHT)
FRIDAY, NOVEMBER 2, 2018
Edward Mintz
*Launch party for Orangerie
aperitif at Konigsberg*

(LEFT)
FRIDAY, NOVEMBER 2, 2018
Kip Dano, Edward Mintz
*Tropical cocktails with the
Anguilla Cultural Council
at Spring*

FRIDAY,
NOVEMBER 2, 2018
Susur Klein,
Edward Mintz
*Anniversary
celebration
for Chez Pluto,
at Chez Pluto*

FRIDAY, NOVEMBER 2, 2018
Zaheera Ben-Abbas, Felicia Summerville, Edward Mintz
*Birthday party and presentation of
"Constitutionally Yours" at the home
of director Jennifer Wiggins*

FRIDAY, NOVEMBER 2, 2018
Edward Mintz
*Special set by DJ Chobani
at Club Touchtone*

THE DREAM II

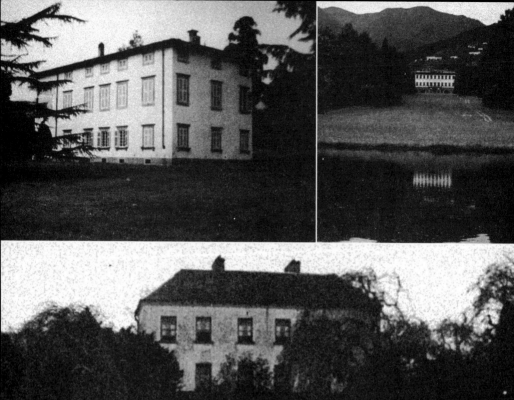

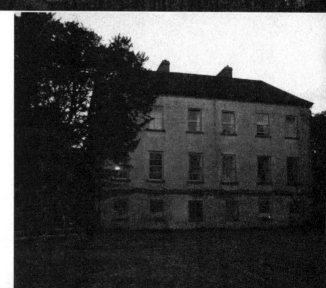

FROM UPPER LEFT: The house in 2009; the house in 1970; the house in 1938; the house seen from the lawn in 2012.

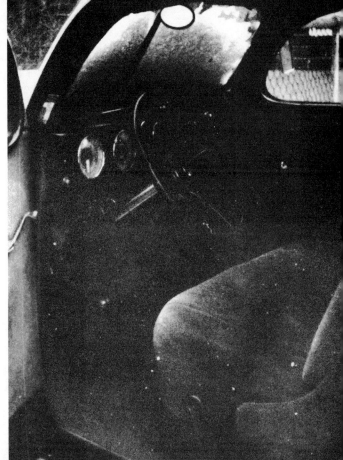

The footwell of the Buick.

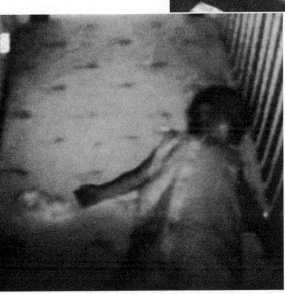

The baby.

A HAUNTED HOUSE

For Leonard Woolf

ILLUSTRATIONS

Plates

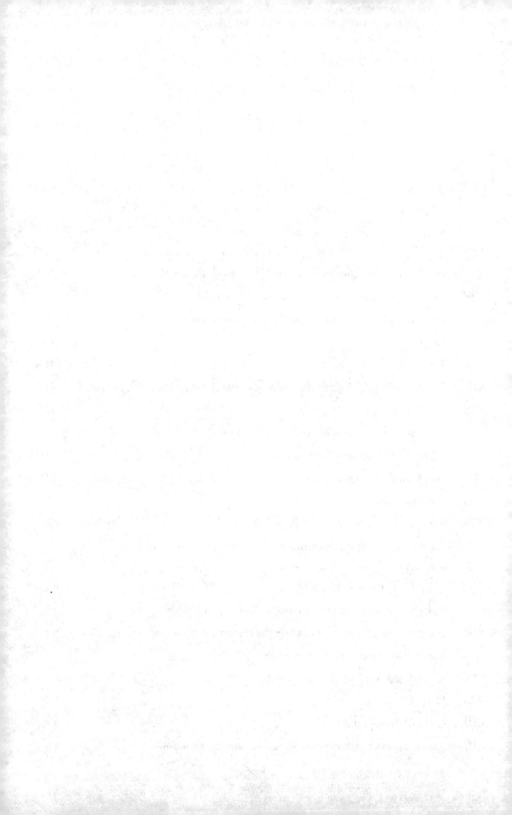

SIRENA DE GALI

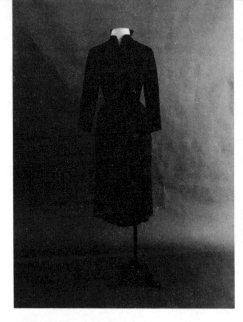

1950s Italian wool suit.
$210.00 or best offer

Vintage woman's suit in black. Gorgeous
boning in peplum. Lined with navy silk, some
staining to silk. Label reads: Brazzoni, Roma.
In fair condition for its age. Sold as is.

*Looking at it, she thought of the morning
interview, the smell of coffee as she passed
the vendors on the street, a revolving door
to the lobby, the elevator to the sixteenth floor.
The receptionist, rude. She would wear red
lipstick and tights and brown wedge sandals.
These details would be noted. The dress would
be immaculately cut; she'd stand straight, taller
in the heels. They'd take her seriously. They
wouldn't notice her stutter or know what to
think of her.*

1940s handmade crepe dress.
$140.00 or best offer

Handmade vintage dress in pink.
Embellished shoulders and pockets. Some
staining to neckline and back. Clean,
except for the stains, and barely musty.

*It was a perfect shade of pink. Not much
blue in it, almost salmon, but dusty.
Evocative of the depressed outskirts of
Toronto between the railroad and the
lakeshore. Mimico, Woodbine, the small
bungalows on smaller streets. The love seats
and wreaths at Christmastime. Ornaments
made of yarn, Popsicle sticks, and Life
Savers. She saw lunch with his family, at
the Belvedere. She'd be a little late, take her
camel coat off to reveal the dress, a flute of
champagne with orange juice. They'd like
her. They'd hope to see more of her.*

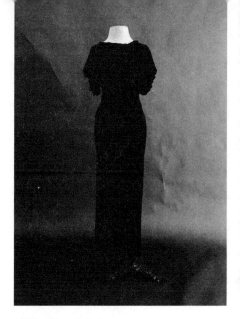

1940s silk velvet dress.
$199.99 or best offer

1940s silk peplum jacket.
$99.99 or best offer

Bias-cut black velvet dress with princess sleeves, some staining, damage to back, and some odor. No label. In fair condition for its age.

She studied the sleeves. Her arms in this should be long, white, even, like stalks of cut tulips. Otherwise it would fit. She'd weave between the tables, past the low benches of the bar, the stained glass, the curtained door. She'd ask for a cigarette, a match. She'd cross her arms over her chest to smoke; she'd shiver.

Button-up black-and-white print jacket with peplum, high collar, puff sleeves. Some staining and wear to back and some musty odor. No label. Fair condition for its age. As is.

A meeting at the V&A Museum, London, then afterward, walking through the halls. She paused in front of a skirt grip in the silver galleries, in front of an Omega Work-shops teapot in the ceramics gallery, and a Dior dress in the costume galleries. There were no other visitors in her mind, just her, the collection, the marble floors, the sound of her boot heels on the marble. The sitter would be expecting her, but she'd be fifteen, thirty minutes late, endure the scolding glance and huff, grateful for the prolonged solitude.

LORNA ALMA ROSSETTI

M. 27·1·1932

Lorna Alma Rossetti in 1930. Rossetti died giving birth to her second child in 1932 and was buried in the Cimitero San Filippo. Her remains were exhumed and stored in the cemetery ossuary in 1950.

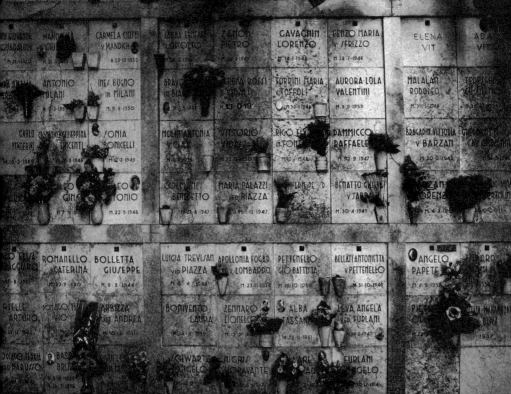

Sirena de Gali, in Calle Domenica, Venice. *The shop website states: Sirena is an amazing repository for all that is vintage, housing an extensive collection of clothing, accessories, textiles, jewelry, and millinery. Our men's shop is famous for its variety. Clothing dates from the late 1800s through the 1990s and is in various conditions. Sirena is not a consignment shop, and we don't carry any sweats, T-shirts, or denim. Visit us often, new arrivals weekly.*

c. 1970s Arnold Scaasi blue silk dress.
$250.00 or best offer

1960s chiffon minidress.
$299.99 or best offer

Floor-length long-sleeved dress, with ruching and bow detail at hip. Some odor, some staining to silk. In fair condition for its age.

White dress with black polka dots, bodice lined in silk, with boning and two petticoats. Some discoloration to back of dress and some odor. No label, probably handmade. In good condition for its age.

Table 10, Markdale benefit. The former ballet principal is seated next to her. His hair is still dark. He asks her about her work, family, where she grew up. His left leg touches hers, a thigh like a melon. He moves, places a foot upon a rung of her chair. He remains like this as they eat. She knocks her red wine into her lap; he dabs at her leg. As he leans in, she can smell his shampoo. He asks her for her place card. Two decades later, in hospital, she tells her daughter about the dinner, about him.

Could she wear it, for the garden party? David will be there. And Shelley, for Christ's sake. Right size, a little short, but cheerful. He'd notice her.

Lorna Alma Rossetti's great-granddaughter Lina Beccaro, a fashion stylist living in Milan.

The handmade dress Lina Beccaro purchased online from Sirena de Gali. Beccaro's grandmother Gioconda saw the dress on Lina and asked her where she had found it. She told her daughter she was positive it had belonged to her mother, Lorna Alma Rossetti, and that she had seen photographs of her wearing it in her casket.

1970s white crepe dress.
$184.99 or best offer

1940s navy wool crepe dress.
$184.99 or best offer

Handmade dress with bishop sleeves and brown rickrack trim. Two long tears at neck. This dress is delicate but could be displayed nicely.

Handmade dress with pleated bodice. Bias-cut skirt. This dress is in delicate condition with some wear to the back.

She'd cried when she opened the package at Christmas. Her mother had made a version of the dress she saw in the magazine. But it was all wrong. Her tears betrayed her hatred of their house, her stepfather. Her tears were hot, and they stung. Through them she saw her mother's face was dark red, with a sad expression. She knew her mother had made it so she could look like the rest of them; she'd sewn it at night. This made her cry harder and feel deep love, and shame.

When Frank came home she knew. About the other woman, but not about the children. Twins. He sat on her bed, after his bath. Took both her hands in his. Her stomach lurched. I'm sorry, he said. He had a ring in his hand; he pushed it onto her finger. I love you. She cried then, and he held her. She let him. He told her he would not contact her, or them, again. She believed him. She went to his bed only once more. When he went overseas again she told his sister. She was her friend.

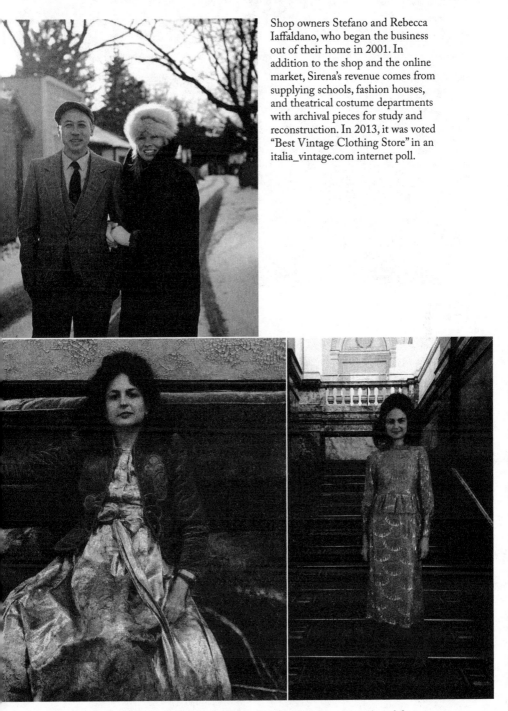

Shop owners Stefano and Rebecca Iaffaldano, who began the business out of their home in 2001. In addition to the shop and the online market, Sirena's revenue comes from supplying schools, fashion houses, and theatrical costume departments with archival pieces for study and reconstruction. In 2013, it was voted "Best Vintage Clothing Store" in an italia_vintage.com internet poll.

Italian stage and film actress Giulia Signorelli in dresses purchased from the shop.

1950s silk chiffon dress.
$199.99 or best offer

Black-and-pink chintz-patterned silk chiffon dress from 1954. Some odor and staining to back and shoulders. Sold as is. It is wearable with these flaws or can be used for inspiration or craft.

She reread the letter. And read it again before putting it on the fire.

1960s hand-sewn wool pinstripe suit.
$210.00 or best offer

Woman's suit. Small size, navy pinstripe, from 1969. Lined with navy cotton, with some staining to back. In fair condition for its age.

In court she will project professionalism, sobriety, conventionality. Her posture will be straight; her lipstick will be perfect. She is the mother. She was the mother. She is the mother.

1970s handmade navy crepe dress.
$160.00 or best offer

1950s handmade bib-front dickie.
$100.00 or best offer

Navy blue handmade dress. Layered yoke collar. Belt missing. Some staining to neck and back. Best for restoration or display, though could be worn with care.

Pink silk with black polka dots. Ruffle collar. In good condition for its age.

Her favorite color was pink. All her life.

Thanks for coming, thank you. It's good to see you, I wish it were not under these circumstances. Thank you. Thank you for your words. I miss him. You must miss him. Thank you. Please have some food.

Elisabetta Mondinori and her sister Vittoria Passera in a photo taken in 1880. Mondinori was buried in the Cimitero San Filippo in 1885. Her remains were exhumed and stored in the ossuary in 2010.

A photo taken in 1961 of Susanna Vecchio. Vecchio was buried in the Cimitero San Filippo in 1975. Her remains were exhumed and stored in the ossuary in 1999.

Carla Bottola in a photo taken in 1952. Bottola was buried in the Cimitero San Filippo in 1999. Her remains were exhumed and stored in the ossuary in 2011.

Sofia Benedetti in a photo taken in 1930. Benedetti was buried in the Cimitero San Filippo in 1991. Her remains were exhumed and stored in the ossuary in 2017.

FREE SHIPPING 1920s bias-cut lacework . . .

FREE SHIPPING Vintage Edwardian velvet . . .

FREE SHIPPING 1970s handmade vintage . . .

FREE SHIPPING Antique gold lamé collar on . . .

FREE SHIPPING Vintage Spanish lace flutter . . .

FREE SHIPPING 1930s cold-rayon dress good . . .

FREE SHIPPING 1930s silk day dress high- . . .

FREE SHIPPING Vintage 1960s boxy linen . . .

FREE SHIPPING Heavy vintage quilted skirt . . .

FREE SHIPPING Cotton embroidered jacket . . .

EQALUSSUAQ

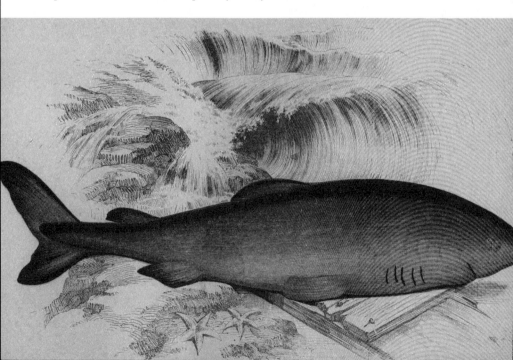

THE GREENLAND SHARK is an inhabitant of the deep North Pole seas. However, every once in a while, it is seen in Dutch waters. Greenland shark meat is toxic and can be consumed only when prepared in a special way. The skin of this shark is used to bind books. Greenland sharks are omnivores. Scientists have found in their stomachs the remains of reindeer, dogs, cats, and even a polar bear. These animals were probably already dead when the sharks consumed them.

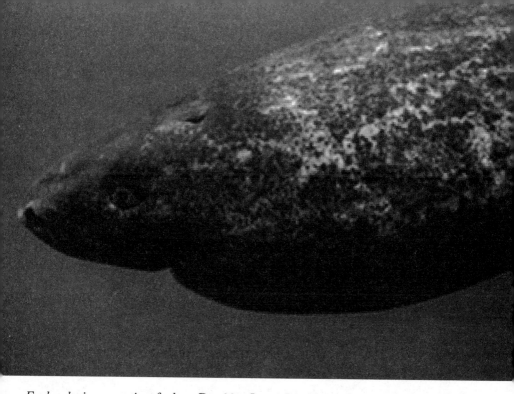

Food and wine suggestions for boat, Dec. 28 to Jan. 4. Breakfast—Basic service should include: fresh fruit plate, emphasizing locally grown fruit / yogurt (local Caribbean) / selection of breakfast cereals, including granola / multigrain bread and/or baguette / freshly squeezed fruit juice (orange/grapefruit) / various jams and honey / tea (caffeinated and non) / coffee, both filtered and espresso / latte / milk, including low-fat milk. Guests should also be offered a cooked breakfast (eggs and bacon) each morning.

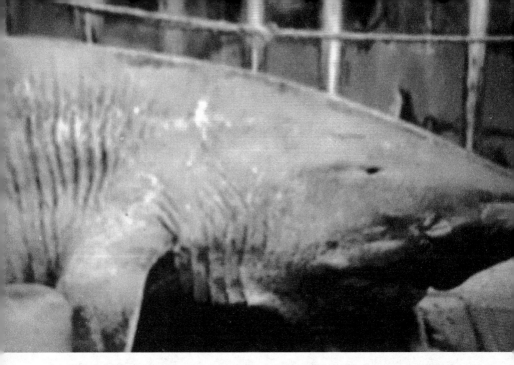

Lunches should consist of three or four dishes brought to the table for guests to help themselves. There might be one hot dish; the remainder should be salad-based. Lunch dishes might include: Grilled fish or chicken, as fillet or en brochette. Pissaladière or similar (not quiche) / Hot pasta with homemade sauce (e.g., tomato and basil; garlic and olive oil; other vegetable sauces). This option probably only served once during the week. Also, please note: we do not care for cold pasta salads. / Salade Niçoise / Asian chicken salad / Vietnamese beef salad / Grilled vegetables / Various green salads, including chopped salads / Tomato and mozzarella / Bean salad (haricots or legume) / Spanish tortilla / Beet salad, avocado salad, etc. / Ideas/flavors from Turkey, Greece, or Spain, as well as the Caribbean, would all be appreciated. / For dessert at lunch, fresh fruit is preferred. Melon and watermelon, and whatever is in season.

The Greenland shark is hunted primarily for its liver. It is caught on a hook baited with seal fat or half-decaying horseflesh. The flesh of the shark when fresh is indigestible and unwholesome: when dried it has a flavor like that of old cheese. It is usually prepared as food by a process of fermentation, the flesh being buried in the ground. When fermented the meat is slimy and jelly-like.

—*The News*, Newport, Pennsylvania, May 15, 1896

CRUSTACEANS CALLED COPEPODS cling to and scrape the eye of the Greenland shark. The resulting scarring on the cornea diminishes the shark's eyesight and eventually blinds it. Any use the parasite might provide to the shark is unknown.

Before dinner: At cocktail hour, a varying plate of charcuterie would be ideal. Prosciutto, salami, a selection of hard and soft cheeses, olives, peanuts, pistachios, potato chips, and vegetable crudités would all be fine. An occasional hot hors d'oeuvre, such as grilled sausages, would also be well received. Complicated cocktail party canapés are not our style, so please don't devote time to them!

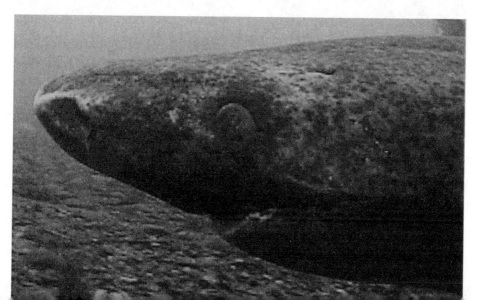

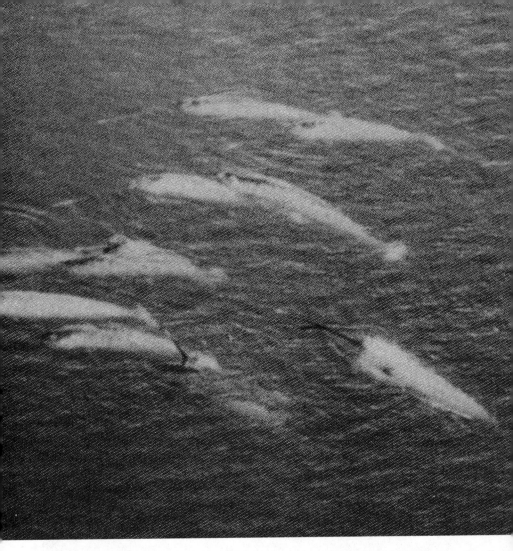

Dinner: If the chef would like to surprise us, the dinner appetizer would be the time. Small plates of interesting, concentrated flavor, making use of local ingredients, would be welcomed. For the main course, we would favor fish/shellfish and chicken over beef and lamb (perhaps a total of two red meat dinners only). In terms of style of cuisine, we would prefer French-Caribbean preparations or contemporary Italian (the River Café restaurant and cookbooks could be a good source). In general, we would not want heavy, cream-based sauces or Iron Chef–style meals marrying too many flavors. This also holds true with presentation: please keep it simple! Fresh cooked vegetables with every meal, please. Local, specifically Caribbean, vegetables very welcome. Potatoes are welcome, but seasoned rice dishes may be better for many nights. Desserts should be modestly sized and simple most nights, and Caribbean recipes would be ideal (though not the very sugar-intensive ones, please!).

"Dad used to say to me that sharks' flesh has a hard time dying. The shark can be rotten, even sticky rotten, and when you touch the skin or the meat it still moves. You know, it is still alive but it is rotten."
—Inuit quoted in Carlos Julián Idrobo and Fikret Berkes, "Pangnirtung Inuit and the Greenland Shark: Co-producing Knowledge of a Little Discussed Species," *Human Ecology,* June 2012

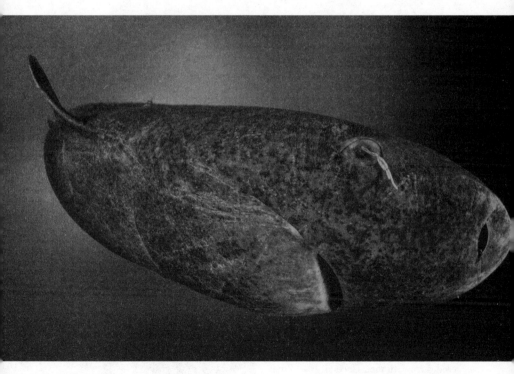

BENTHIC COPEPODS POSSESS mouths perfectly adapted for scraping and eating the bacteria that grow on organic detritus. Other copepods, found in plankton-rich cold water, feed in the spring and summer months, consuming more than half the volumes of their bodies. Most copepods, though, like fish lice, feed on their hosts.

Drinks: The usual assortment of soft drinks—tonic, Coke, Diet Coke, ginger ale—plus flat and carbonated water (Badoit, if available). If the Caribbean grapefruit soda called Ting is available, please also include. Plus: Fresh coconut water, fresh limeade/lemonade.

Dead but still eating: Some of our selachian members may be members of the order of Greenland sharks, which are big but cowardly. They feed on dead whales, tearing great mouthfuls out of their carcasses, but they never attack the whalers, though the latter are not slow to prod them with their lances; it is said that they will go on gorging themselves with blubber long after they have received a mortal wound, and when, if they had any sense, they would know that they were dead.
—*New-York Tribune,* December 12, 1897

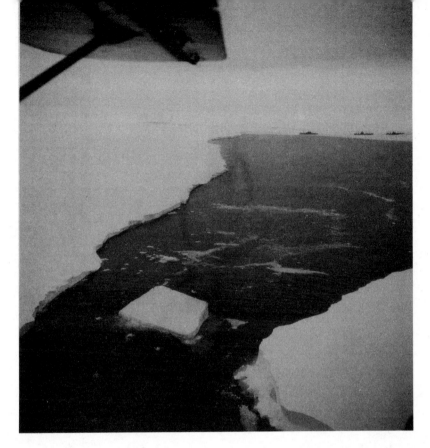

Alcohol: Premium vodka, light and dark rums, gin (Hendrick's, if possible), whiskey/dry vermouth and olives for martinis. Caribbean cocktails: ingredients for Rum Punch/Planter's Punch; sweetened fresh lime juice for Rum Collins/Tom Collins and Vodka Gimlets; pineapple and orange juices; grenadine; Angostura bitters. Wine: Three white wines should be available. One case of each of the following: Spanish Albariño; Italian Pinot Grigio; South African or New Zealand Sauvignon Blanc. Two cases of a good-quality French Provençal Rosé (Domaines Ott would be preferred). One case of red Pinot Noir, Napa or Oregon origin. N.B. If you have a supplier's wine list, please forward to us to choose from.

A Norwegian Antarctic explorer, H. J. Bull, gave a startling report of a shark's tenacity of life. This man-eater was caught at the Iceland cod fishery: his liver, heart, and internal arrangements were removed, so as to put a period to his career, and the thus mutilated body was then cast into the sea. He simply gave a leisurely wag of his tail and swam rapidly out of sight.

—*The Tampa Tribune*, October 8, 1911

NATURA MORTA

107 likes

98 likes

233 likes

152 likes

185

125 likes

143 likes

186

102 likes

222 likes

187

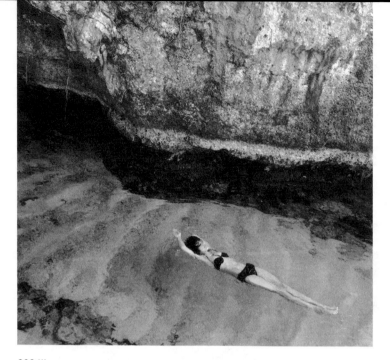

202 likes

104 likes

157 likes

140 likes

189

267 likes

146 likes

99 likes

127 likes

THE ICEBERG AS VIEWED BY EYEWITNESSES

ILLUSTRATIONS

Plates

I. *Joseph Scarrott, an able-bodied seaman aboard the* Titanic, *sees the berg not more than one hundred yards off the starboard beam after the collision.*

II. *A photograph of what was believed to be the iceberg that sank the* Titanic, *captured by Czech sailor Stephan Rehorek from aboard the German cruise ship* SS Bremen, *on 20 April 1912.*

III. Titanic *iceberg.*

IV. *The iceberg that sank the* Titanic.

V. *A view of the iceberg believed to be the one the* Titanic *hit, from aboard the* Carpathia.

VI. *George Rheims, a* Titanic *passenger, steps out of A deck bathroom forward and looks aft as the berg slides by.*

VII. Titanic *iceberg.*

VIII. *Mrs. Mabel Fenwick, a* Carpathia *passenger on her honeymoon, photographed the iceberg from the* Carpathia's *deck on the morning of 15 April.*

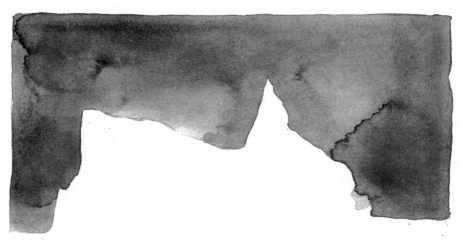

I.

Communication between restaurant and bar
still needs improvement. The restaurant was
proposing tables for the bar. I would suggest
be more strict about it. Kelis Baum was
informed she wouldn't be able to come to
the bar by Catroina and Jeff. Ms. Baum then
approached a new waitress in the restaurant,
who walked her straight in.
TBL 6: Four people + high chair increased
from four to five + high chair. Phone call
confirmed by PT came in for brunch on 2.2.
Baby got stuck in a high chair and waited a
very long time for food. Overall they were
not impressed, but Kevin dealt with it.
Please look after on next visit.

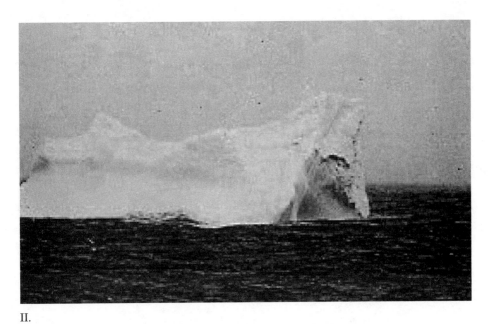

II.

Restaurant needs to brief all staff about restaurant/bar relationship and operations. It is completely understood, accepted, and supported by the bar staff that saying "No" to restaurant guests regarding entry to the bar should be down to bar staff and NOT restaurant staff so they may maintain good relations with restaurant guests BUT . . . it has been observed that there is often an unsupportive attitude from the restaurant once the "No" has been delivered.

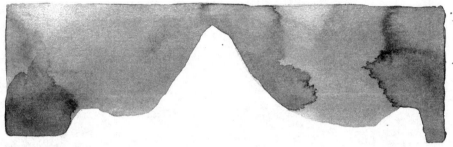

III.

"I'm sorry, there is nothing I can do, it's nothing to do with me [hands raised in the air whilst shaking head], if it was down to me of course you would be let in" vs. "I'm sorry, the bar is a separate operation to the restaurant. Now that the hotel is open, the bar is primarily for hotel guests and their guests. I know the bar team accommodates our very important clients when they can, but it seems they are unable to do so this evening, I'm terribly sorry."

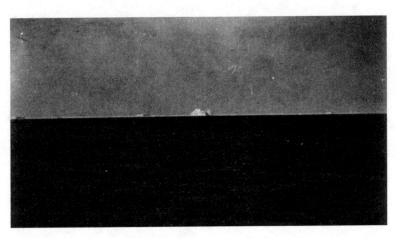

IV.

Security 1. Lucas had an encounter with paparazzi at the front gate when Jessie Macksamie arrived. Ms. Macksamie's driver parked on the pavement, three feet from the gate. Her security tried to shield her from the paps. In trying to get between gate and car, one pap got pushed inside the gate by the security. When asked to leave, he refused and pushed Mark aggressively (Mark received a small cut to his neck), and Mark pushed him back to get him off. The pap held on to Mark's scarf and wouldn't return it. All witnesses agree that Mark only acted in self-defense and even then acted with restraint.

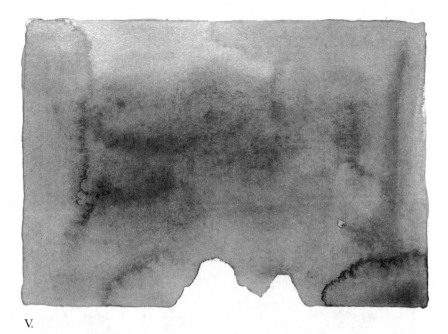

V.

Bobby Gordon (had dinner with eight
guests) entered the bar through the lift after
being told it wouldn't be possible for them to
enter this evening. They were very unhappy
and aggressively rude to both Catroina and
Jeff. Quote: "Well, I know for a fact that the
fat bitch I met in the elevator is not a hotel
guest, so you are lying to me!" PG Director,
Higham Gallery New York Ltd. Lives on
Euclid Street. Came in for brunch on 2.5.
Waited a long time for food.

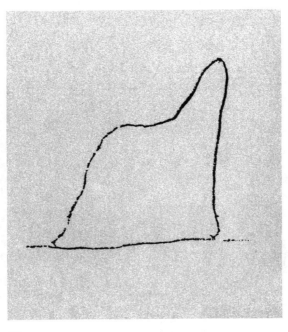

VI.

Jake Neil (owner Hebrides) pushed his way
through the bar door, refused to even engage
in civil conversation, and stormed around the
bar looking for hotel guests who could say
they were friends of his so he could stay.
He was very impolite and aggressive with
Catroina and the maître d' team.

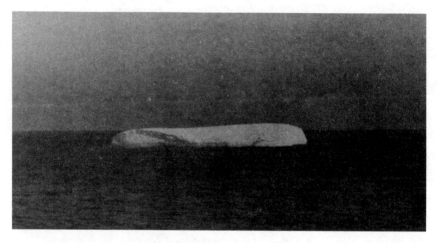

VII.

Ian Keith showed up wanting to come back
later with guests. Jules and myself informed
him of the situation and that he could
come back with only two guests. He came
back with six, including Hector Lethese,
Alex Peter, and Miloz Czeh. I let them in
without knowing that Jules had already
texted him to say it wouldn't be possible.
We have discussed communication
breakdown. Won't happen again. Alison
Poole showed up with eight guests. We
told her that tonight it wouldn't be possible
with so many. She accepted this (at first)
and left grumpy.

VIII.

Caroline Leith and Taylor Tune showed up
at one a.m. with five guests. Very drunk and a
little difficult at the gate. One of the standing
lights by the entrance flickered when dimmed
and one of the rope lights had fallen through
behind the bench by the fire; both of these
matters were dealt with by engineering. Clive
Benenson and Lily from Hoppers came down
for a couple of hours to experience and see
if they would be happy recommending us to
the "right" guests and vice versa. We spoke
at length and they have invited me down on
Saturday night to experience Hoppers.

OVER THE WALL

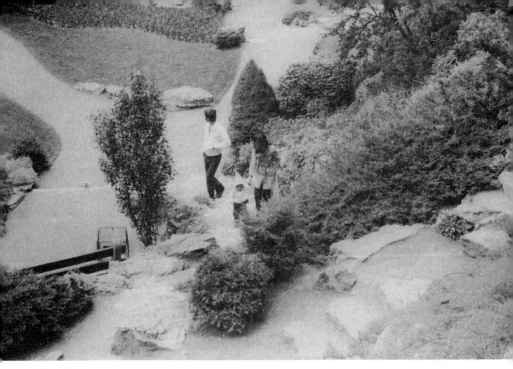

Deep in the woods.

Along a dirt trail.

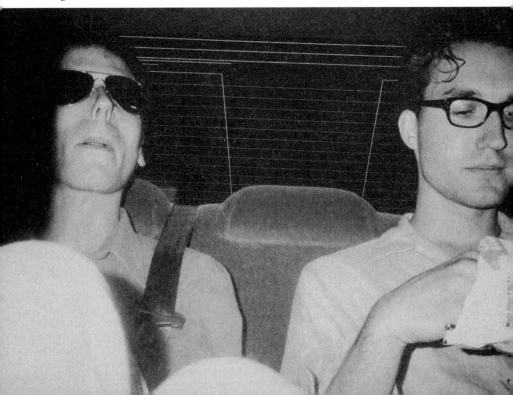

Past the stone gates.

Over the wall.

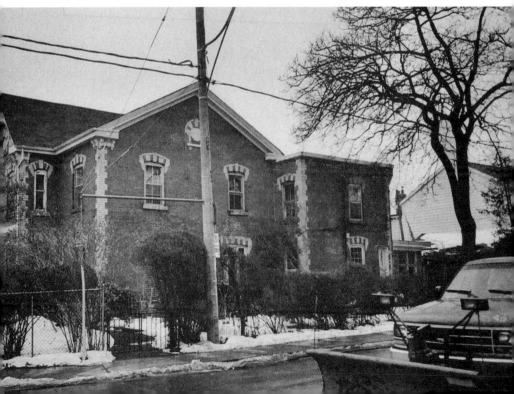

Where the path ends.

A falling-down barn.

An abandoned house.

An old schoolhouse.

Nobody knew they were there.

The ruins.

They would meet.

Nobody saw them.

GEORGEHYTHE PLACE

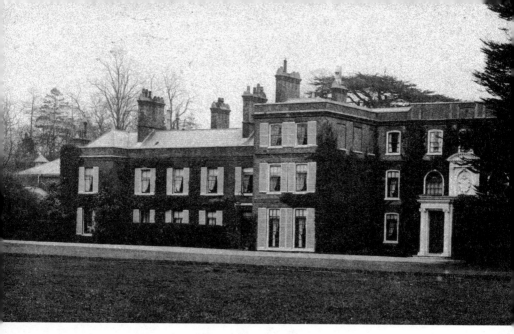

Georgehythe Place in 1965.

GEORGEHYTHE PLACE, owned by the Percy family since 1804, stands at the end of a mile-long drive from the main road. The house is an ivy-covered stone mansion on the outskirts of Goldbourne, backing onto what is claimed to be the largest water meadow in England. The oddest feature of the interior is the double asymmetrical hall.

The old manor house, Chautmarle, once occupied the site of the present house. It was destroyed by fire in 1799, save the east wing, which sits at an angle to the hall and boasts original oak paneling. One east-wing bedroom features a Venetian window.

Georgehythe was rebuilt by William Tyrol Jr. in 1812. Tyrol was a master of Jacobean Revival, as was his father. In 1926, the shipping tycoon William Kingsley tried to demolish Georgehythe Place to build row housing. After a public outcry, he sold it instead to the Peal County council, which merely neglected it. Scores of dogs and cats lived in the building for years. Restoration was planned in the late 1930s but was delayed due to the occupation of the house by American troops, lasting until 1945. Since then the house has fallen into disuse, but the gardens have been used as community sports fields, and the lakes and ponds for annual county-wide regattas.

A number of curious tragedies befell the Percy family, all preceded by the sudden presence, absence, or death of animals. This prompted local paranormal authorities to consider the family as possessing an unusual example of what is known as a "family ghost."

Left to right: Etta Kingsley, Beth Kingsley, Anna Drebbin, Sir William Letts (father of Sir Anthony), Lady Melgund, Lady Helen Percy, Gwen Letts, Lord Charles Percy, and Lady Evelyn Percy.

Lady Helen with Lady Evelyn, who was recuperating from one of her many bouts of illness. She is seated at the base of Ashes, the Georgehythe landmark. In her hands she holds a bird.

Lord Charles Percy, age four, around the time he noticed the appearance of animal bones in the back of his wardrobe. He kept them wrapped in a scrap of linen in his desk.

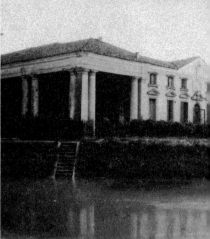

Helen, Reginald, and Evelyn Percy on Beausoleil Lake, south of Georgehythe, a month before Reginald's death by drowning in Beausoleil Pond. Each year on the anniversary of his death, unexplained water stains appear on the oak paneling in the east wing.

Beausoleil Pond.

Lady Helen Percy with her terrier Derby and an unknown child. Derby was killed in a motoring accident the day before Reginald's drowning and was buried with Reginald in the family plot.

The east hall, showing some of the mysteriously water-damaged paneling.

Beausoleil Pond at Georgehythe was filled in and made a garden in the year after Reginald's death.

The hall at Georgehythe, where the German governess Fräulein Siebeck groomed Mucky the day of his disappearance.

Lady Helen Percy with her spaniel Mucky at Georgehythe the year she fell ill with tuberculosis. Mucky disappeared the day before she died.

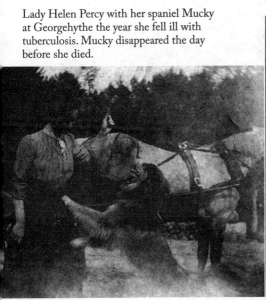

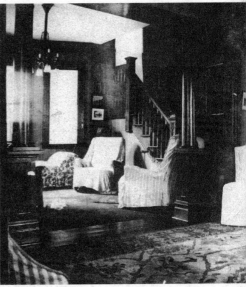

The music room at Georgehythe, where the remains of Mucky were recovered during minor renovations in 1942. The room is located directly above the original east hall.

The main staircase at Georgehythe, where Theresa Percy twice saw three large black dogs soundlessly descend the stairs.

Anna Drebbin holding her cat Cucko. The ca[t] lived to fourteen years but disappeared while Evelyn Percy was in labor with her son Dunc[an.] She died in childbirth.

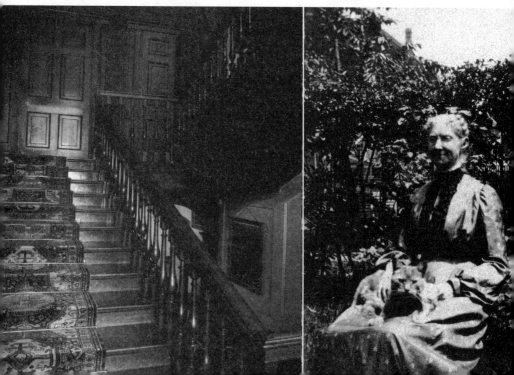

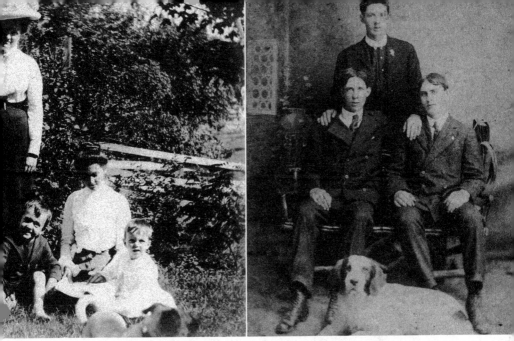

Duncan Percy, age three, with Georgehythe neighbors and a dog. Duncan began raising spaniels on the grounds of Georgehythe as a boy.

Duncan Percy, standing, with friends and Hilda, his prize spaniel. Percy and Hilda were involved in a motoring accident in 1933. Hilda perished at the scene of the crash, her master the following day.

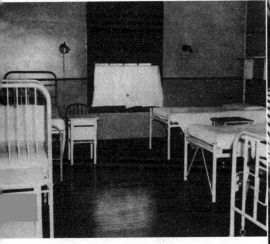

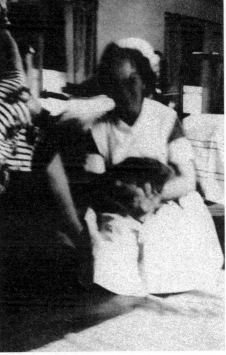

Georgehythe's east wing, during its incarnation as an infirmary during the war.

Kelly Finch, a nurse who worked at Georgehythe during its occupation by American soldiers, holding a cat. Finch recorded in her diary that the day before the death of Private Jonathan Lynch she discovered two dead jackrabbits under his bed.

ALCATRAZ

She looked me in the eye and said, "This is a true story." We were at a dinner party, a casual one in someone's enormous, expensively fitted kitchen. She had come alone, was recently divorced. I'd met her before, but we'd never really spoken or found common ground. I'd always thought she was chilly. When we were sat next to each other at dinner and got to talking about books and people we both knew, I realized her shyness was the blurry, foggy kind—reserved, but not cold.

She told me she had been visiting San Francisco with her boyfriend, who would become her husband, and then her ex-husband. His name was Troy. It was early days. Troy was there for work, and they stayed in a suite on the fortieth floor of the Four Seasons. She sipped her wine and said she had not been used to hotels that nice. The square footage. The sitting room. The enormous white towels. They'd had a driver. She'd been to San Francisco before, when she was ten, during a stopover on a family trip to the Philippines. They'd stayed with her mother's Filipino cousins in a small house, and she'd slept in a bottom bunk with her brother. She told me she'd drunk a whole can of Coca-Cola for the first time in her life that night, and she laughed.

The day after they arrived, Troy had meetings, so, she said, she decided to visit Alcatraz. She laughed again and said that as a teenager, she'd worn a pink-and-white sweatshirt that had been sent to her by those same Filipino relatives. She described the puffy white stencil-style letters that read *Alcatraz Swim Team* above a flocked blob of the famous island.

We were offered coffee at this point, and some of the guests had moved to the living room, but we stayed in the kitchen and poured ourselves more wine. She boarded the ferry and took the thirty-minute guided tour with a handful of other visitors, listening closely as the guide explained the routine of an Alcatraz inmate, its history as a military prison that held Confederate sympathizers during the Civil War, the designation of bunks, the block called "Park Ave" where the prisoners, on certain nights like New Year's Eve, could

hear the sounds of the city across the bay and were served spaghetti and better-than-usual food in the mess hall. The guide boasted that "the *crème de la crème* of criminal minds came to Alcatraz."

When the tour was over, the guide invited the visitors to wander the site for as long as they wished. She returned to what had been the library. She described the room as fenced-in, large, and bare, with peach-painted walls, empty wooden bookshelves, and tall barred windows. She stayed in that room a long time and thought of the prisoners reading books. She remembered the safety and escape she felt as a child, in libraries. She retraced the tour backward, pausing to take pictures of the cells where two prisoners had successfully escaped by leaving dummies in their bunks. She stayed for hours, watching as a new tour was led through, looking at the glossy green- and cream-painted walls, the bars, and the corridors. Finally she left, late afternoon. They had reservations for dinner in Berkeley that night, and she said that as the car had crossed the bridge she'd looked at the dark rock of Alcatraz in the middle of the water, and violent thoughts, bloody, ferocious thoughts, had filled her mind. She shook her head.

That night she woke, unable to move. The space in the bed beside her was empty, and there was a man sitting in an armchair in the corner of the room. Both of his hands were placed along the rests, and his legs were stretched out on the ottoman. He was still. She tried to call out for Troy and to move her fingers, but she was frozen and unable to speak. She remained in that state for a few minutes, and then she was finally able to make a small noise and push her arm an inch across the sheet. She sat up. The toilet flushed, and Troy returned from the bathroom. She whispered to him that someone was in the room. He turned on the bedside lamp. The chair was empty. He looked around the room and went into the sitting area. Nobody was there.

The next day she and Troy visited the San Francisco Zoo. She said that she wore a skirt and, in the car, put a hand up her skirt and scratched herself hard. She described walking around the zoo as agony. She had wanted to touch

herself in the aquarium, looking out over the manatee swimming slowly in its round pool, at the pacing lions, at the gorillas. Out by the llamas she straddled a children's ride, a toy duck, and moved atop it for some relief. Back in the car she reached up her skirt again and told Troy she needed to go to a drugstore. They flew home that afternoon.

For the next week, back at her apartment in New York, she was distracted every few days by the sensation of a cat brushing past her legs. She did not own a cat, but she would turn and look down at her feet. There'd be nothing there, and she'd go back to whatever she was doing. The feeling of a gentle brush against her legs persisted for another week, then another, always with the same, invisible result. She began to wonder about it and told Troy over dinner one night. He asked her if she felt anything when it happened. She told him, "Sadness." The word had only then occurred to her, but it was true. Troy asked when it had started. She told him it had started in San Francisco after visiting Alcatraz. Then he told her that he thought something had attached itself to her at Alcatraz. He told her that when he first visited the prison he'd become obsessed with the story of Robert Stroud, the "Birdman of Alcatraz." When he got home he walked into his apartment to find that a bird had flown in while he was away and had shat all over his furniture.

The next morning, as she was pouring milk into a bowl of granola, the cat-brushing-past feeling happened again. Troy told an acupuncturist friend about what was happening. After thinking hard on the details, the acupuncturist told her that the spirit of a prisoner had attached itself to her at Alcatraz, that it sought the sympathy she felt for the men who had been there, sympathy they'd desperately wanted. The acupuncturist suggested that she take off all her clothes, have Troy burn sage in circles all around her, open the windows in the apartment, firmly ask the spirit to go, and then leave the windows open for the rest of the night.

LAGO

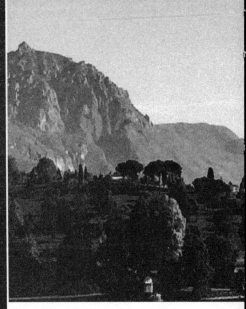

View of the lake.

Interior.

Dining room table
in sitting room.

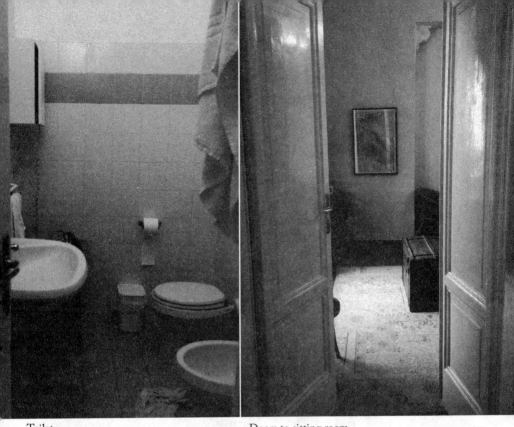

Toilet.

Doors to sitting room.

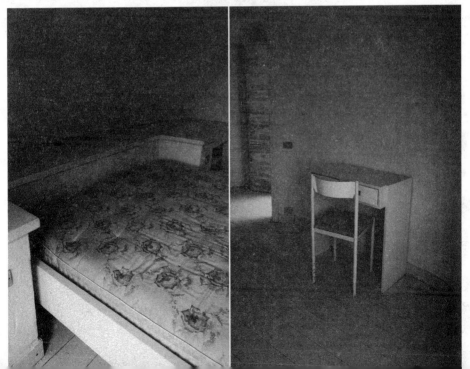

Guest room.

Desk.

Sitting room.

Sitting room.

Bedroom window.

Bedroom.

Bedroom.

Bedroom.

Bedroom.

Bedroom.

View of the lake.

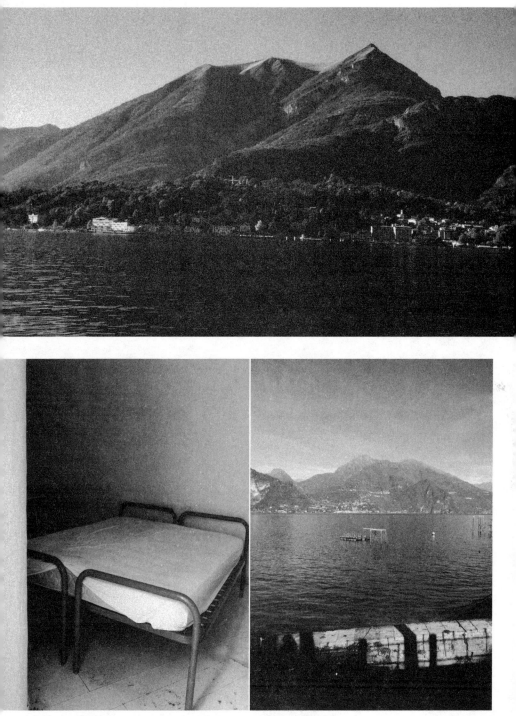

Guest room.

View of the lake.

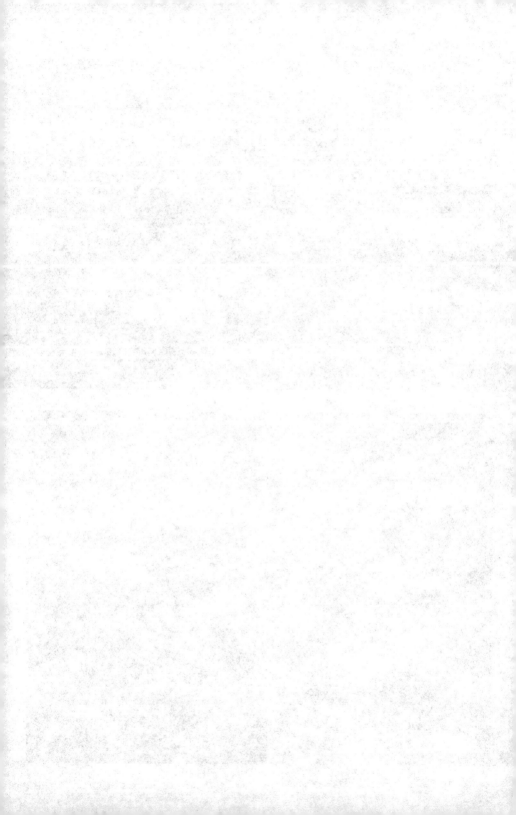

NEW JERSEY TRANSIT

I was walking down the street because my plans were delayed because my ride was canceled because I don't like to improvise. I was walking down the street and the night was falling and the streetlamps were lit and there I saw you leaning against the mailbox reading your phone.

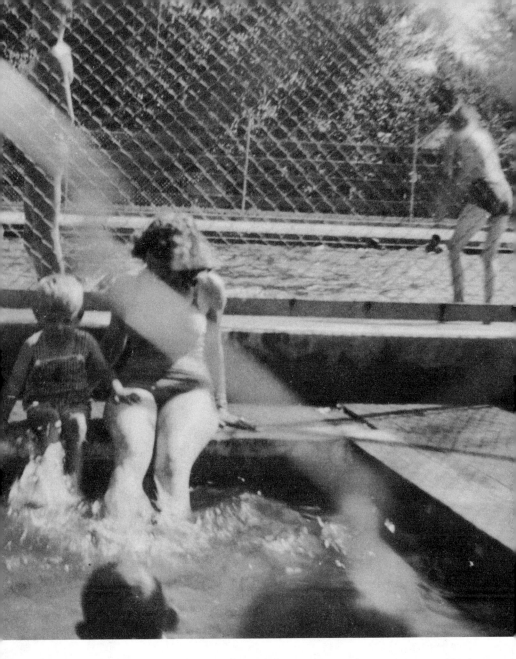

I saw you and I slowed, then stopped. I thought you were with our son. I thought if I left town you would be with our son since that was the plan, I mean generally, I mean so to speak, so we had spoken, not that we speak, I mean.

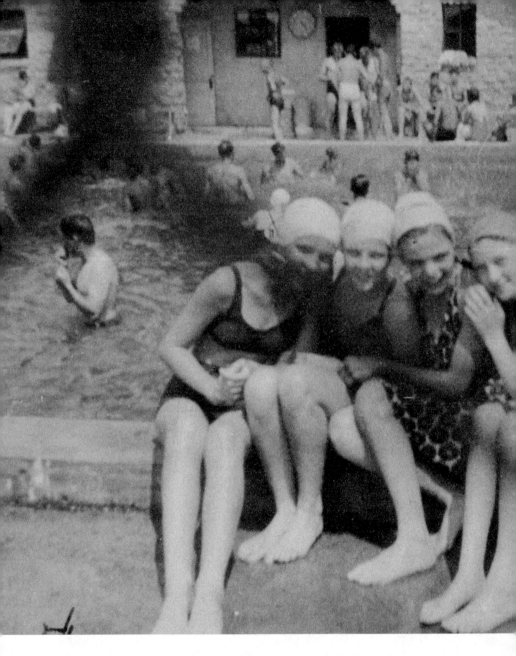

I stood still and looked at you from behind a very thin tree. You would not have seen me anyway, but still I put the tree between us, and I watched you outside my building leaning on the mailbox and my overnight bag was in my hand and I was not sure what it would be like where I was sleeping, I had never been to Princeton anyway but there you were. And presumably upstairs there our son was.

Then a black car drove up and you waved to the driver and got in the backseat.
I stood on the sidewalk and was suddenly not there, in your mind, in his mind, in my own
mind. I was of no minds. I had lost part of my own mind but not in the crazy way, more
in the blank, not-knowing way, like, BLANK.

Not knowing why you were leaving our son but knowing he was up there in my apartment and not knowing why I was leaving I mean really why. I mean. It was a white lie and I was going toward it. When you question why you are going are you really going?

I was transparent; not wearing lipstick, carrying an overnight bag, some watercolors, some brushes, my computer and pills. I felt myself fade out, then I stepped out from behind the tree and started walking again. I faded back in.

WHO IS THIS
WHO IS COMING?

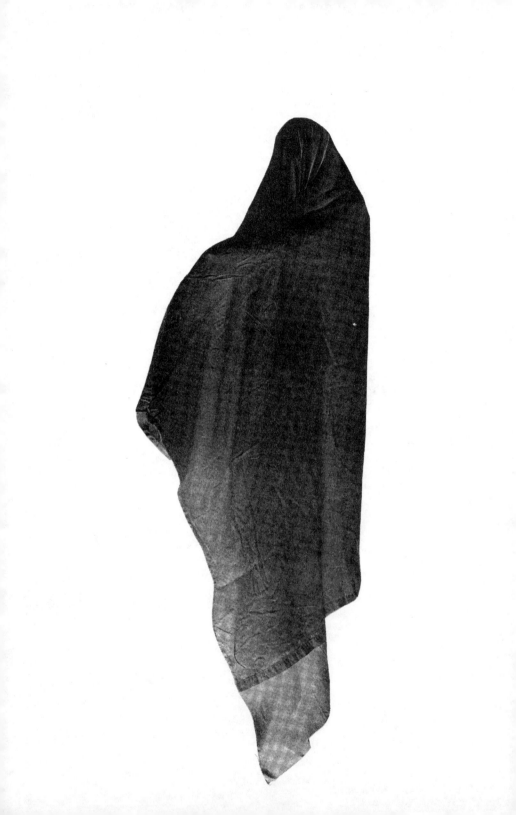

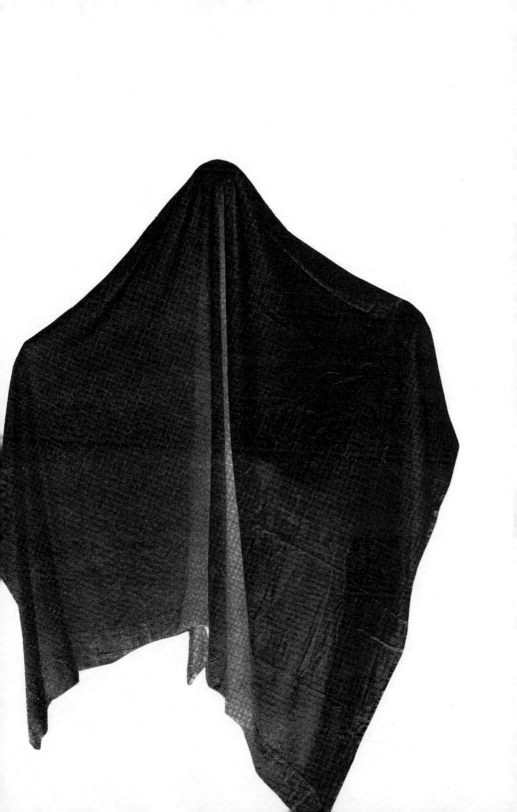

ÊTRE CHEZ SOI

LAMENT: I don't feel at home at your place / Your daughter lives here / You need a new mattress / You're out of Listerine / Your ice cubes smell funny / Can you get me a towel? / You don't have any salt, do you? / I stacked the dishes in the sink / I think I'm allergic to your couch / Your sofa cushions smell / Your neighborhood is all rich people.

You never stay at my place / I hate my apartment / I love my apartment / The tub's a little dirty / Glad you stayed / I'll do the dishes, I guess / No, I'll do them / I think you should go home.

A children's birthday party, riverside, on an autumn day. The wind picks up as the light falls. The kids run in circles on the grass, the air and exertion making their cheeks pink and cold. The sky is overcast. The mothers pack up what is left of the fried chicken, the boxes of organic juice, the bucket of wine coolers.

On the walk home, with every step, she says to him, "I hate you."

I hate you, I hate you, I hate you, I hate you. It gushes from her, leaves her breathless and puzzled. She holds her daughter's hand while her daughter holds a lollipop from the loot bag in the other. The night before, she'd cried quietly in the backseat of a car, repeating: *I hate you, I hate you, I hate you, I hate you.* Then vomited violently in the sink and the toilet before bed.

She wants to be in her room, before dinner, with her mother cooking downstairs. The smell of meat browning, the sound of the refrigerator opening and shutting, the cold closing darkness at her window behind an orange wool curtain.

The sunset strikes the highest windows of a building while a bus sighs.

Suddenly: an aboveground swimming pool covered in plastic solar sheeting on a warm, overcast summer day. She's at her father's sister's house. She loved that house. It was nothing special. A split-level semi, but it was a life like in the books and ads. There was wall-to-wall carpet in blue whorls, and whipped cream from a can, and butterscotch sauce. In the winter an ice rink was shoveled into a rectangle at the elementary school down the block. They'd skate on a Sunday night. Skate in the half-dark before supper and in the dark after supper. The house would be lit by strings of blue Christmas lights. Then her cousins moved. An East Indian family moved in. The father hanged himself in an upstairs bedroom.

THE NECKLACE WAS EXACTLY AS SHE'D IMAGINED IT. She looked adorable, *adorable*. Adorable in exactly the way she wanted to be. She would wear it when Katharine came over. When Katharine came over she would be wearing it, and she'd put some wine on ice in that ice bucket she found last weekend, and put out some cheese and crackers, and she'd just be wearing it with a dress and an apron as Katharine was just stopping by, just popping by in the afternoon, and she'd just bung the wine in some ice and fling some cheese on the table and that would be that.

THREE OF THE GUESTS HAD BROUGHT FLOWERS, all roses. The thorns hadn't been removed on the yellow, the most beautiful, ones.

Three of the guests stayed late. One of them offered to do the dishes. *No, no, I love doing dishes.* The other two smoked and talked at the windowsill. The host, who ran a lecture series, could not decide if he was a guest or a host. He chose guest.

The next week was his birthday and he was staying with friends. That night, after dinner, his hosts brought a birthday cake to the table. On it were the numbers 4 and 3. In that order. He was shocked. *That's a wake-up call!* He laughed aloud, then blew out the candles.

As he lay on a bed in the guest room he told himself he wanted children, a relationship, a job he liked, stability, roots. He pulled the duvet up around his chin. He preferred being a guest.

The yellow flowers wilted and died, and he kept the dried flowers on the table, thinking dried flowers were still beautiful, but they never really are, are they? Still, he did not throw them away. They made him feel loved. They were dead, though.

His last girlfriend had not loved roses. She liked ranunculus, anenomes, tulips, and poppies. He had loved her but she was difficult to please. She had adored him for all the qualities she herself had once possessed. He felt her doing this, but he did not protest. She had children, a job she liked, stability, roots.

And he had adored her for the qualities he felt he possessed. She was fun, he told his friends, she liked the same things, same music, they were so compatible. He'd never loved someone like this. He liked how he looked, to her.

One morning, as he was standing in the bathroom, he saw her pick up her phone and put it down again. She turned to him and told him she liked sleeping with him. He liked sleeping with her too, but he did not tell her. Slowly he grew jealous, possessive, suspicious. If she could see things in him, then she must see them in everyone.

Then, one day, he stopped wanting her qualities. He resented her qualities. He resented the fucking ranunculus. Roses were beautiful. He did not feel like himself anymore. There was too much pressure to be himself, and when he was alone and not inhabiting her qualities, he felt guilty. He suggested a break. She was angry and sad. She looked at him across the table then, and she saw him as she had the first night they met. He looked at her as she took back the qualities that she had lent him, one by one. Blood came into her cheeks. Until she was herself again. Until he was himself again.

THE CHILD HAD CRIED, *Don't leave, Mommy. I don't want you to go.*

Her mother shushed her and gently smoothed her brow.

I'm here.

She looked at her phone. Twenty minutes late. Restaurant ten minutes away.

Don't go, Mom, Mommy. Promise me you won't go? Tell the sitter to go home.

She rubbed the child's back in slow circles.

I'm here, love, try to sleep, I'll stay with you.

The child lay on her stomach and closed her eyes. Soon she slept. Her mother stepped into the hall, left the door ajar, applied lipstick in the hall mirror, and turned to the sitter.

If she wakes, just say, Shh, shh, as though you were me, and soothe her without talking. Otherwise I'll be ten minutes away if she needs me.

When she worked at the newspaper, she had to do a story on corporal punishment. She ordered paddles, whips, canes, and rulers from various sex-supply websites. These items arrived at the office wrapped in plain brown paper. She sent them to the art department to be photographed, and a day later they were returned to her desk.

She put the ruler in a coffee cup along with her markers and pencils, put the other items in a drawer. The cane was too long, so she hung it over her desk partition alongside an umbrella and forgot about it.

She told her boyfriend about this one night, over spaghetti. She saw his eyes narrow and sensed something pass between them. She felt suddenly older.

Then her boyfriend told a story, about remembering her before they dated, when she had come to his office with a few other editors. He said when he felt lonely, working late, he'd think back to that day and how happy he'd been to see her. *You had a blue-and-white-striped sweater on,* he said. But she did not own a blue-and-white-striped sweater, it was her coworker Gina who had worn that. She twirled spaghetti on her fork and decided not to correct him.

SINFOROSA

I was home, visiting my parents for the weekend with my daughter, Alice. My parents were happy to see her and gave Alice toys to play with that I'd never seen before—old dolls and plastic baskets. When I asked where they had come from, my father said they had found them in the free area at the dump. After lunch one day, as Alice played in the living room, my mother told me a ghost story.

My mother's father had died in a mining accident when she was eight. Her aunt Sinforosa, his sister, told her the story. Sinforosa said that on the night my mother's father died, he came to her and slept beside her. My mother said this in a quiet, matter-of-fact tone, with a firm look in her eyes. She told me that as children, her father and his sisters had all slept together on the floor, under the blankets. Sinforosa had told my mother that she knew it was her brother because of his feet. "I know his feet," she had said. He had come back to her, to them as children.

I asked my mother if she had ever seen his ghost. She said she had not. But once, she said, she was visited by the ghost of a teacher. He was her favorite teacher, and he had a smell of soap. She was a favorite of his too, and at school he paid special attention to her. The night he died, she said, she woke up and her bedroom smelled strongly of him, of his soap. She knew he was saying goodbye, she said, as she picked at the tablecloth.

THE COUPLE

He had a reputation.

He fell in love. Over and over again,
in love. He cried a lot.

Thank you, he'd say,
when he ended things.

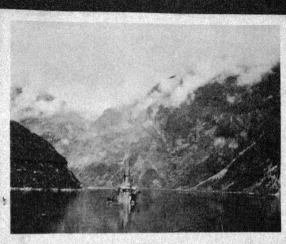

She was an only child.
Never pretty.

She spoke in bon mots.

He was easily seduced.
Could she save him?

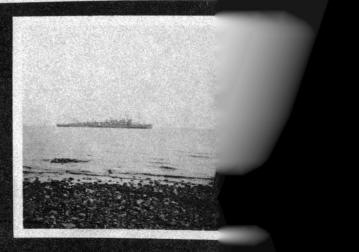

Power.

Presentation.

He was a man who lacked true
tenderness. Acted tenderness.
She was a woman who lacked true
charisma. Acted charisma.

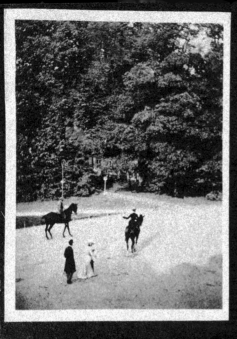

No matter what they did.

No matter how many parties
and stories.

Something was off.

Three syllables.

Sounds like.

Royalty.

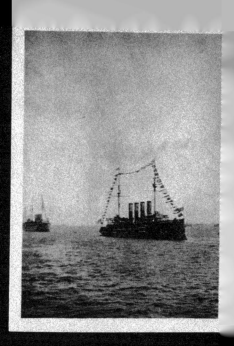

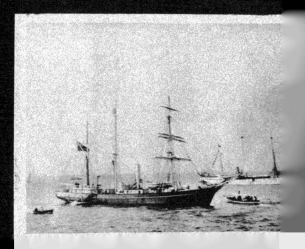

THE DREAM III

The icehouse, where bodies were kept
until the ground thawed.

TABLE PLAN

The table
plan.

The cellar.

CHRYSANTHEMUM, CARNATION, ANEMONE, FOXGLOVE

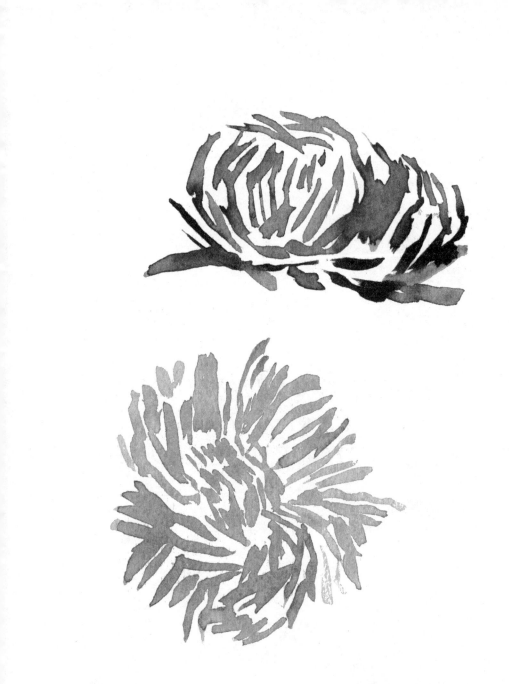

LIVING WITHOUT what the photo does not give back. What you don't see. What you don't get to see. Think about what you don't get to see.

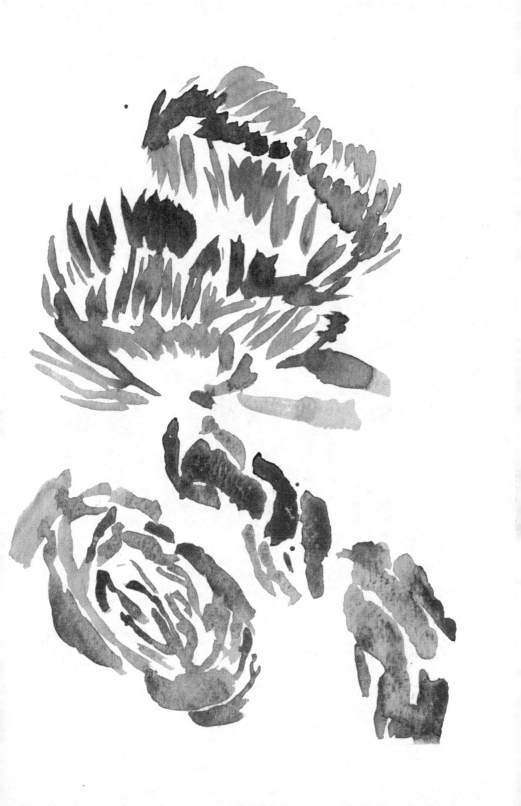

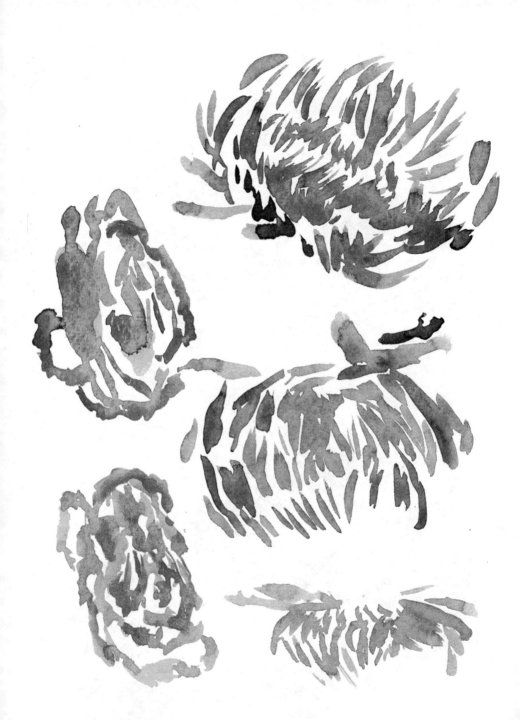

Remember what you don't get to see.

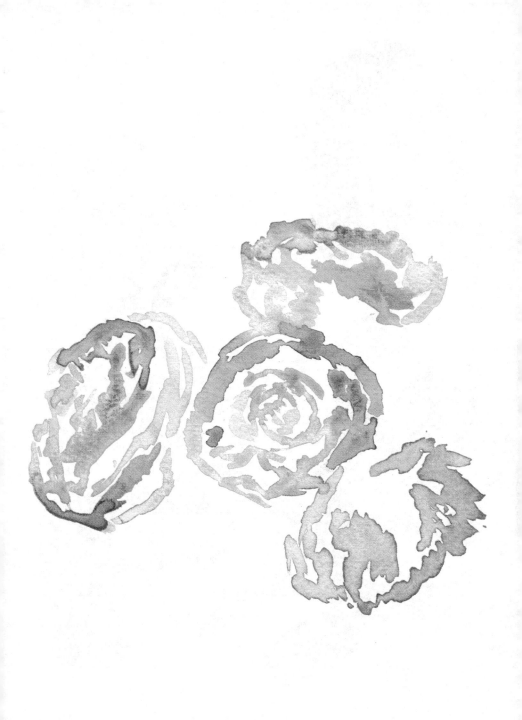

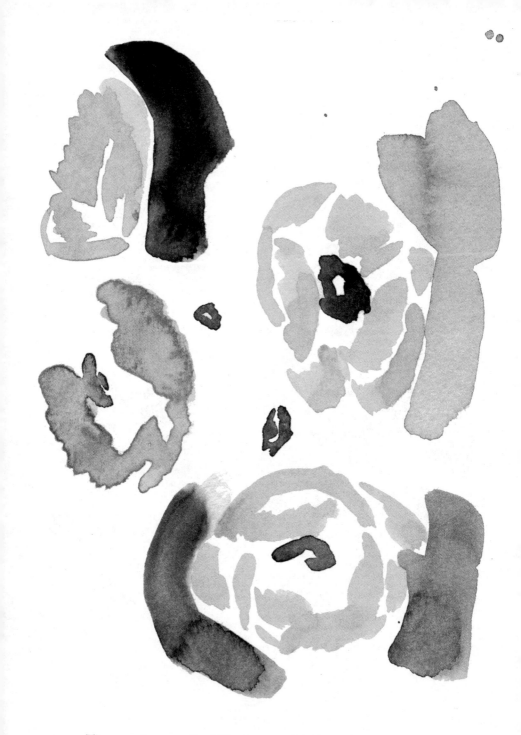

The never, but ever-fixed. The latency of the latent image.

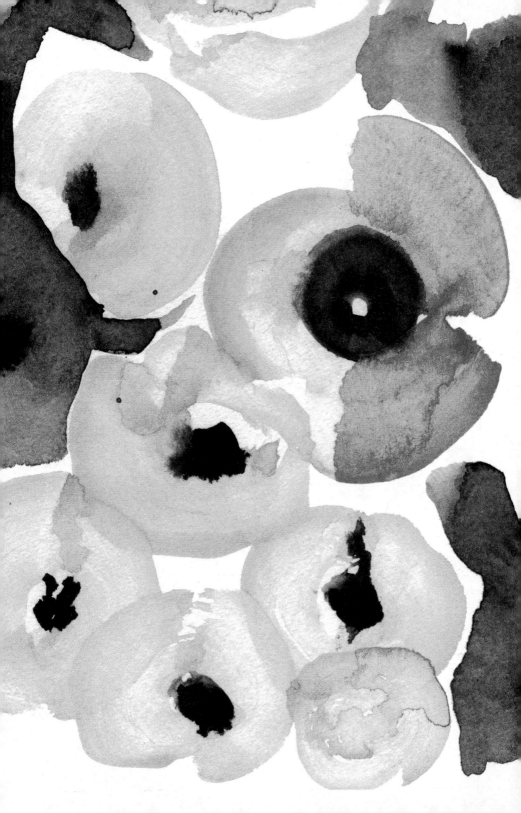

It is there in the dark. It was there. It is still there.

CAUSETH SATH

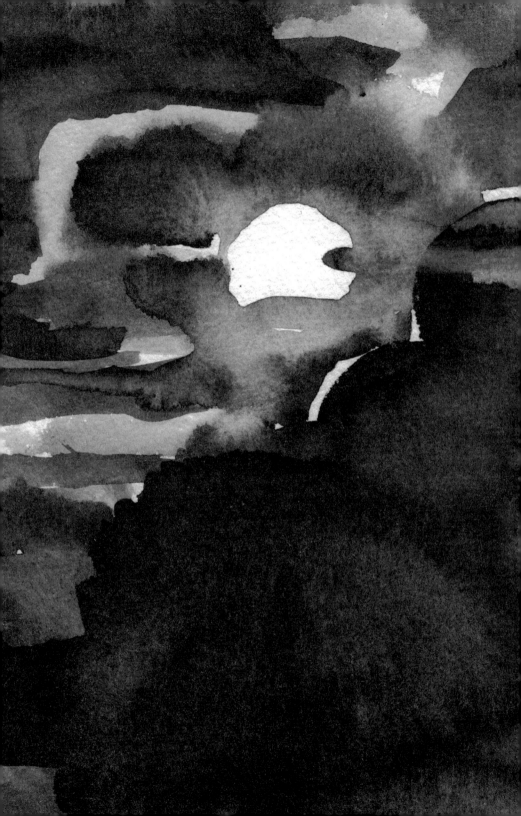

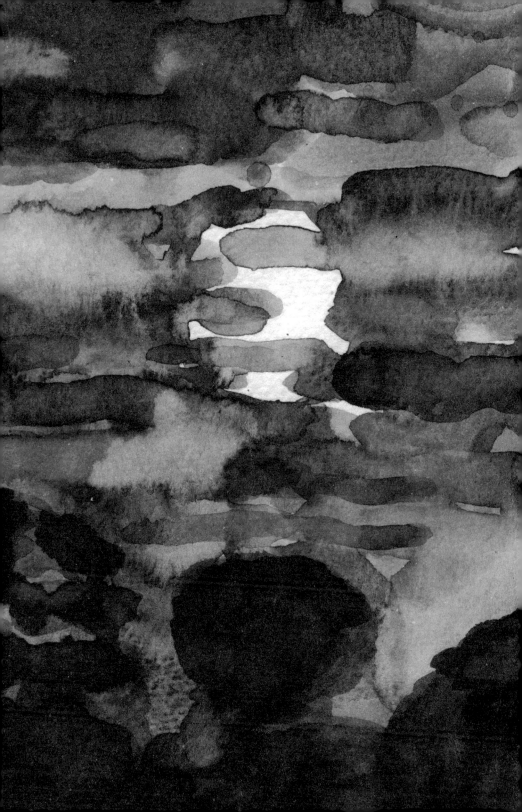

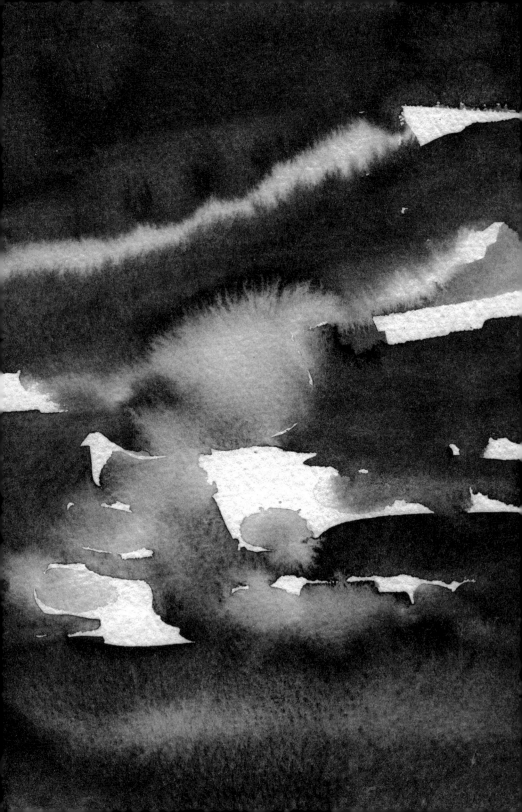

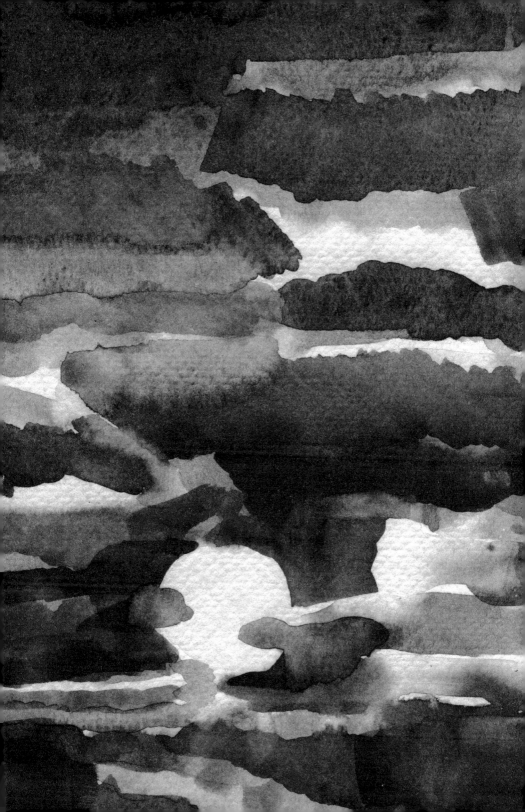

ACKNOWLEDGMENTS

Thank you to my family: Bob and Lorna Shapton, Derek Shapton, Kristin Sjaarda, Pamela Baguley, Joyce Atkinson, and Tomasina Truman. Thank you, Richard McGuire, John Geiger, Kristin Gore, Jessamyn Hatcher, Lisa Naftolin, Michael Schmelling, Mark Wallinger, Adam Thirlwell, Brendan Canning, Kim Temple, Jessica Johnson, Ken Whyte, Sara Angel, David Shipley, Ian Maxtone-Graham, Maile Meloy, Aria Sloss, Rachel Comey, Ceridwen Morris, Rivka Galchen, Dede Gardner, Jerry Schwartz, Friederike Schilbach, Christopher Wahl, Chris Bollen, Gaby Wood, Judith Clark, Emily McDonnell, Juman Malouf, Monique Bureau, John Wray, Christoph Amend, Carla Gilders. To Sarah Chalfant and Luke Ingram in London, Rebecca Nagel and Andrew Wylie in New York.

Thank you to Riverhead Books: Becky Saletan, Anna Jardine, and Helen Yentus. Especially to Claire Vaccaro for patience and design. Many thanks to Teddy Blanks for work on the cover and Kate Ryan for photo research.

Thank you to my geists: Sandeep Salter, Carson Salter, Jon Drennan, Milah Libin, Christine Coulson, Holly Carter, Christopher Noey, Steven Estok, Deirdre Foley-Mendelssohn, Christine Muhlke, Christian Zaschke, Gabrielle Bell, Peter Mendelsund, Ruby Mendelsund, Maggie Parham, Jim Parsons, Michael Portnoy, Oliver Helden, Cynthia Barton, Ben Metcalf, Batsheva Hay, Maya Singer, John Derian, Liana Finck, Carolyn Kormann, Sarah McNally, Jasper McNally Jackson, Jeff Eugenides, Frank Barkow, Nick Kulish, Yelena Akhtiorskaya, Laura Ferrara, David Gilbert, Victoire Bourgois, Lucas Wittmann, Brendan Francis Newnam, Adelaide Docx, Gwen Smith, Joseph Medeiros, K. Todd Freeman, Paul Graham, Olga Yatskevich, Chris Johanson, Reed Birney. Enormous gratitude for friendship, grace, and skill to Paul Marlow, Gus Powell, Jason Fulford, and Jason Logan.

Special thanks to Sheila Heti, Heidi Julavits, Taryn Simon, and Niklas Maak, for being early readers, supporters, and note-givers, and to John Jeremiah Sullivan, for close reading. Thank you, James Truman, for the days.

PHOTO AND ART CREDITS